BRIGHOUSE AT WORK

CHRIS HELME

AMBERLEY

First published 2017

Amberley Publishing
The Hill, Stroud
Gloucestershire, GL5 4EP

www.amberley-books.com

Copyright © Chris Helme, 2017

enquiries@chrishelme-brighouse.org.uk

The right of Chris Helme to be identified as the Author
of this work has been asserted in accordance with the
Copyrights, Designs and Patents Act 1988.

ISBN 978 1 4456 7072 0 (print)
ISBN 978 1 4456 7073 7 (ebook)

All rights reserved. No part of this book may
be reprinted or reproduced or utilised in any
form or by any electronic, mechanical or other
means, now known or hereafter invented,
including photocopying and recording, or in any
information storage or retrieval system, without
the permission in writing from the Publishers.

British Library Cataloguing in Publication Data.
A catalogue record for this book is available
from the British Library.

Origination by Amberley Publishing.
Printed in the UK.

wm 369

The Versatile Turret Miller

For milling, boring, and jig boring at any angle, keyway and end milling, die sinking, mould and pattern making. The machine illustrated above is fitted with table power feed and slotting head as extras.

Illustrated left; the WM 369 at work at the
P & N Tool Co. Ltd., Uxbridge.

Write for illustrated brochure :
'The WM 369.'

WOODHOUSE & MITCHELL

**WAKEFIELD ROAD
BRIGHOUSE YORKS**
PHONE :— BRIGHOUSE 627 (3 LINES)
GRAMS :— 'WOODHOUSE BRIGHOUSE'
WM. 28

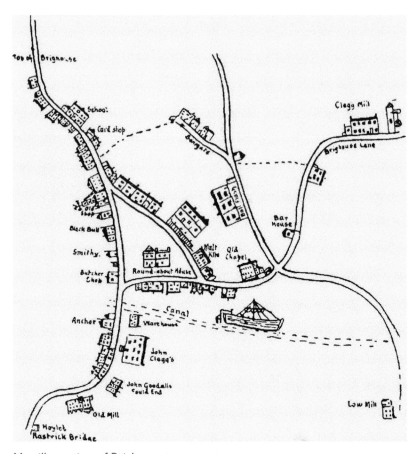

Map illustration of Brighouse town centre.

A rare hand-drawn map of Brighouse town centre dated 1799. Some of the named buildings on this map still exist in the present town centre. In 1799, the canal was thirty-nine years old, and to the left of the barge is the Anchor Inn and warehouse standing alongside a line of buildings – today the Daisy Street car park. The Black Bull is clearly shown, as is a school that was financed by Mary Bedford – one of the local worthies – from her will in 1741. Bonegate is also clearly visible and has connections with a local soap works industry at the bottom of Bonegate Road. Ball Flash can be seen coming down into the town centre from Bonegate – this is the section of Bradford Road between Lloyds Bank and the Yorkshire Building Society today. There is also reference to the malt-kiln that stood on this site from the 1600s and was demolished to make way for the new town hall in 1887. With the amalgamation of the districts in 1974, the town hall was no longer needed. In 2003, it was taken over by a dental practice. The original old Park Chapel is shown having been built in 1795 and is now the Wetherspoon's hostelry The Richard Oastler.

The two oldest mills in Brighouse are seen on the right-hand side, one of which is Clegg's Mill, built in 1785 and later known as Little John Mill – still its postal address today – which can be seen at the bottom of what we now know as Clifton Common, on the corner with Oakhill Road. The second of these is Brighouse Low Mill, which is shown on the bottom right-hand side. The mill predates 1816, when it was sold by Sir Georgee Armytage of Kirklees Hall at public auction for £4,500 to Calder & Hebble Navigation Co.

CONTENTS

ACKNOWLEDGEMENTS

Thanks go to all those who have kindly allowed use of their photographs and given information for this publication.

To the A. F. Tait 1845 print Brighouse courtesy of the National Railway Museum/ Science and Society Picture Library. Michael Halliwell for use of his canal image and Marshall plc Southowram for use of their West Lane Works 1954 photograph. Humphrey Bolton for his Brighouse and Rastrick Band roundabout photograph. Crosslee plc for use of the aerial photograph of the company site. Rachel Bray Jeremy@theboathouse.com for use of an internal photograph of the restaurant. Stuart Black for his Brighouse railway station opening photographs and the Kosset Carpet Queen photograph. The photograph illustrating Brookes No. 1 engine is courtesy of Andrew Gill (2007) and thanks go to Dr A. Cowling at the museum for locating this image for me, used by arrangement with the Middleton Railway Trust Ltd. Stuart and Mark Wardingley for information about their family wire business, J. W. Lister Wireworkers. Paul Thompson for help with the history of his family business, Thompson and Munroe. Gary Heginbottom for the photograph outside his business premises, Artisan Fireplaces (www.artisanfireplaces.co.uk). Hallmark plc for allowing me to visit their Brighouse distribution warehouse and take photographs – special thanks go to Dion Irish and Ann Dolan for showing me how the gift wrap conversion machines worked and Chris Clay for his help and guided tour of the warehouse. Mr Robert Fitton and Mrs Christine Horbury for information and help relating to their father, Mr Noel Fitton of Ambassador Radio and Television. The owners and staff at ROKT Climbing Centre, Brighouse, and Luke Murphy for use of a photograph of him climbing up the side of what was Sugden's Flour Mill (www.rokt. co.uk). Mr David Illingworth of Sherwood Coating Brighouse for the historical background to his family business on the Armytage Industrial Estate (www.sherwoodcoatings.co.uk). Malcolm Bull (www.calderdalecompanion.co.uk) and his British Car Auctions for the background information of their Brighouse operations (www.british-car auctions.co.uk/Auction-centres/ Brighouse/ Leach Colour Ltd). Thanks also go to Mrs Susan Jagger – for her help with the history of her family, the Brooke's stone company, Edward Field and, finally, to John Brooke for his patience and very helpful proofreading of the book.

INTRODUCTION

Brighouse is fortunate in having possessed a wide and diverse variety of different trades and industries. One of the oldest, if not *the* oldest, is the stone trade, which has existed in the district for 300 years – possibly longer. Another is the wire industry, which has probably been in existence even before the stone trade. Since those far-off days, Brighouse and its surrounding communities have seen the birth of many new industries, particularly since the Industrial Revolution (1760–1840).

The key to the creation of a prosperous and progressive industrial community is its transport links. With stretches of the River Calder unnavigable at various points, including at Brighouse and through the Calder Valley, consideration was given to constructing a canal in 1740. This idea was initially objected to by mill owners, who thought such a project would leave them short of water for their mills.

In 1757, an Act of Parliament was passed to make the River Calder navigable from Wakefield to Salterhebble by constructing a canal. Three years later a Brighouse had its own canal, constructed by James Smeaton, the engineer who built the Eddystone Lighthouse. He was assisted by James Brindley, who was to become the foremost canal-building expert of his time.

If you look across the canal basin today, it is difficult to imagine that it was once Brighouse's industrial hub. It has been described as an inland port that received and transported non-perishable goods and materials along the canal networks. These networks also lead to coastal ports and the eventual trans-shipment to ocean-going vessels. From the town's basic industries of stone quarrying, from 1837, over a twenty-five-year period, wire, woollen textile mills, card clothing and cotton soon followed. The industrial diversity of the town had changed considerably.

The decline of the canal network started soon after Brighouse opened its first railway station in 1840, and then further with the expansion of road transport. Today, the canal has seen a new lease of life with pleasure boats, and many of the original old mills are being used once more, albeit with alternative uses.

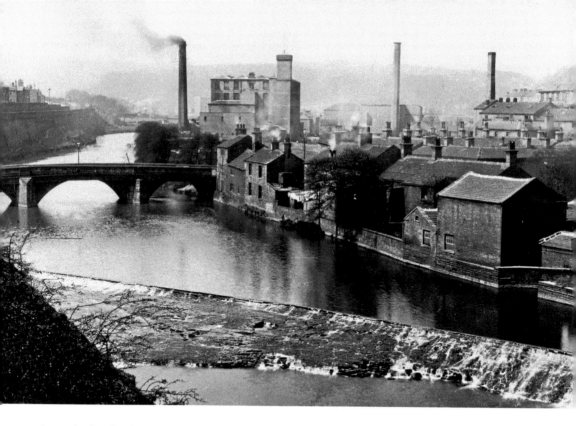

A way had to be found around the unnavigable parts of the River Calder. The solution came in 1757 when the Calder & Hebble navigation canal was constructed. This carved a route almost through the centre of Brighouse. It enabled barges to collect payloads from the mills and factories built alongside this valuable new transport system, described as the motorway of the time. These loads could be delivered as far as the east and west coastal ports, with a final delivery by ocean-going vessels to overseas destinations. Brighouse was now an exporter.

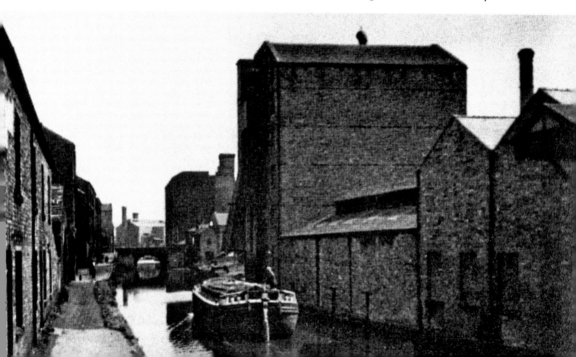

FROM RICH PASTURES TO UNTAPPED WEALTH

At the turn of the nineteenth century it was written that a cultured gentleman from the south of England visited the northern counties. At the conclusion of his visit he wrote and published a journal about the areas he had visited. One of the notable passages in the journal relates to his journey when he left Huddersfield and passed through a well-watered and wooded area, then came to the top of a hill overlooking the valley below, at a point between Brighouse and Elland. He described the view as one of unsurpassed loveliness, wooded hill and cultivated dale, combining to make a scene of natural beauty and grandeur that equalled anything he has set his eyes on in the whole of his journey.

Over the next hundred years, that view of Brighouse and its surrounding communities would change considerably. A variety of new trades and manufacturers would open a new industrialised business community in the area. The very existence of Brighouse would never rely solely on one particular industry.

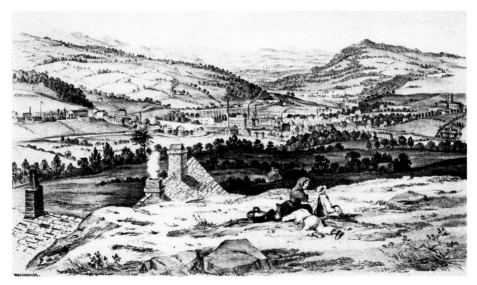

Overlooking Brighouse from Clifton Common, c. 1845, showing some of the early mills in the valley below.

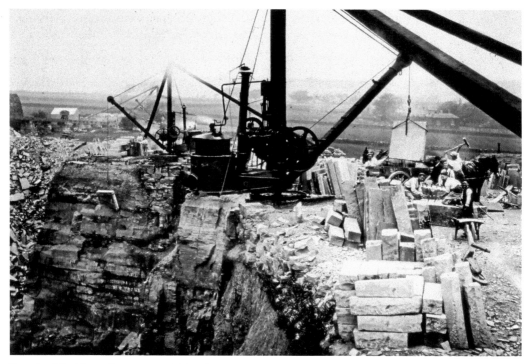

Brookes' Stubbins Quarry on Halifax Road, Hove Edge. The Silex stone is being quarried from at least a depth of 24.5 metres from the bottom bed, where the hardest stone was located.

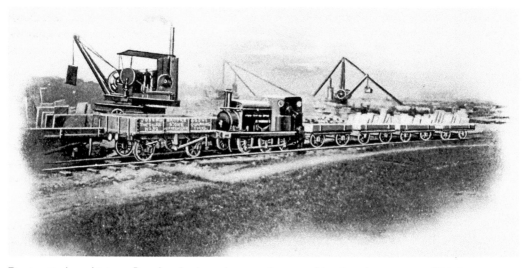

During its long history, Brookes had ten locomotives working for the company. This image shows the company's first locomotive, which was given the name *Silex*. The company placed the order with the Leeds company Manning & Wardle on 21 October 1896; it was dispatched from the makers on 7 January 1897.

The new locomotive proudly displayed the company name, Joseph Brooke & Son Ltd. In 1934, after thirty-seven years, the locomotive was scrapped. This image shows *Silex* at Pearson Brow, Hove Edge, collecting Silex flags for the company's many customers in London.

One of the earliest documented references to stone quarrying dates back to 1416 when the prioress of Kirkleys (Kirklees) arranged for stone to be brought to the priory from a quarry in Rastrick.

Up until the Industrial Revolution, most industrial processes at that time were carried out by hand. Life was tough, but things were gradually going to change. These changes are reflected in the census returns, where men would change occupations from being agricultural workers to stone dressers, flag fettlers and stone cutters – all working under the direction of a quarry master. This was where these men could earn a higher income. However, during the eighteenth century quarrying was extremely difficult. As yet there were no powerful cranes or hardened steel chisels, so these men – new to the industry – had to work very hard for their wages.

Two major commercial stone companies were started in the nineteenth century. In 1840, Joseph Brooke founded the stone and granite quarrying firm of Joseph Brooke Ltd. His sons – Aspinall, Newton and Willie – later joined the company. Being the oldest, Willie was head of the company from 1876; however, he died in August 1903 in a railway accident at the Lightcliffe Tunnel. Newton was next in line, and succeeded him as head of the company. Brookes was to become firmly rooted in the stone industry, with some twelve sites in the Hipperholme and Lightcliffe district and an expansion into quarrying granite in Westmoreland, Guernsey, Wales, Norway and Sweden. Its big breakthrough was in 1898, when it patented the first non-slip artificial paving stone. This revolutionised pedestrianisation and was soon in great demand throughout the country – at least fifty local authorities were customers. The company had their own steamship to carry stone to such places as London, and also its own branch railway line.

The company expanded into architectural stone masonry, housebuilding, brick-making and Hard York Stone products. The business later went into making bitumen road coatings and supplying hardcore for road-building and repairs. Following the 1916 Low Moor (Bradford) munitions explosions, the War Department decided to allow smaller companies to apply for a licence to manufacture picric acid for the use in high-explosive shells. This saw the birth of Brookes Chemicals Ltd, a satellite company to the quarry business.

Following a period of large-scale contraction after the Second World War, Brookes closed in 1969. Although the company is no longer with us, the Brooke family name lives on with Newton Park, a street in Hove Edge, along with Brookville, Brooklands and Brooke Green, three streets in Hipperholme.

During its history the company had ten steam locomotives, but the only one that has survived the test of time is *Brookes No. 1*. This was built in 1943 and used at Brookes Chemical Ltd and is now based at the Middleton Railway and Museum as part of a popular visitor attraction in Leeds.

The second major stone company to be started in Brighouse is Marshalls plc. This is a business that straddles the Brighouse and Halifax boundary at Southowram. In 2004, Marshalls celebrated its centenary of becoming a limited company. Within that century the company and market changed far beyond the family's expectations.

The business was started by Solomon Marshall (1847–1914), who lived in Hove Edge, Brighouse, and worked at the local Pond Quarry in Lightcliffe Road as a foreman. By 1895 he could see there was a good living to be made out of this kind of work and made the decision that the most lucrative way for him would be to establish his own business.

His early work saw him mining to a depth of 60 feet and working across an 8-foot bed of stone. His decision to start his own business proved to be a good one, and neither he nor his family would ever regret it. It was 21 March 1904 when the business was first registered as

Marshall's West Lane works in Southowram, 1954 – a rapidly expanding business.

S. Marshall & Sons Ltd and, with his five sons, he was able to buy land to sustain stone reserves and ensure the long-term future of the business.

A major advancement for the company came in 1922 when the old steam-powered cranes could be replaced with electric ones. By the 1930s the company was working land in both the Brookfoot and Cromwell sites. Both areas were being developed extensively now by the more modern electric crane and supported by gangs of skilled masons. The company was looking to maintain its competitive edge and took a big step forward when it introduced compressed air to power its drilling. As an intensive labour industry, this was progress, and it was one of the first companies in the area to make such an advancement.

The process of 'winning the stone', as it was referred to, produced some waste. It was a situation the company had to try and resolve, even in those days, just as it is now. Recycling is an important consideration. The company began to sell the unused, wasted stone that was not suitable for building at a reduced price to Brookes, a competitor based at Hipperholme. They then used it in their concrete paving plant. After Brookes closed in 1969 Marshall's continued to recycle the unused material.

Marshall's invested in purchasing their own flag press and began to crush the unused stone, mixing it with cement and water to create their own pressed flags. This was Marshall's first venture into manufacturing concrete paving. This new flag product was patented in 1937, which saw the birth of their new 'Marshalite Artificial Stone'.

In 1947 a second production site was opened at West Lane, Southowram, producing lintels, steps and fence posts. Another major step forward was the introduction of Tungsten Carbide drill bits. These supported new drills that could drill to depths of 70 feet, way beyond that had previously been possible.

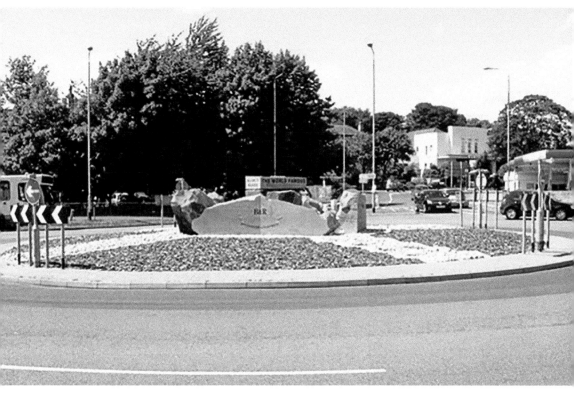

In 2006, a team of representatives of Calderdale Council, Marshall plc and Brighouse & Rastrick Band headed by the mayor of Calderdale, Councillor Colin Stout, met to discuss a plan to design and install a permanent monument to the Brighouse and Rastrick Band in recognition of its role as a leading ambassador to the town and district. Months of hard work by the team followed, which eventually paid off, culminating in an official completion ceremony on 15 May 2007.

Through gradual expansion, the company acquired Stockton Stone & Concrete, Norton and William Heaton from Maltby in 1969. Then, a year later, they purchased Brookes, who had been its business rival since 1904.

Marshall's block paving is something that is taken for granted now, but in 1972 it came about due to a downturn in the home-building market, which then led to the company experimenting. Examples of this kind of paving can be seen all over the United Kingdom, as well as on many sites overseas.

The 1980s saw a boom in the DIY market, which saw Marshall's increase their product range both for the domestic and commercial markets.

Looking back, Solomon Marshall would be pleased with how the company has grown and developed such a wide product range. His family and the generations that have followed have built on the family values that he put in place all those years ago. He saw an opportunity while working as a foreman in Pond Quarry, an opportunity he grasped with both hands. From his small band of quarry workers, the present company now employs over 3,300 people. The company, now trading as Marshall plc, continues to experiment and expand in new technology and products – long may it continue.

Clifton, a small hilltop village community that overlooks Brighouse in the valley below, was essentially an agricultural village; however, it was at one time a centre for coal, wire-drawing, leather tanning and card-making for the production of woollen cloth.

Written evidence of coal in Clifton dates back to 1308 when Richard Naillour of Clifton paid 6d (2½ pence today) into the manor court to be allowed to dig sea coal. Prior to that date local people had just been helping themselves. Surface coal was collected in the village from the fourteenth century, but from the 1840s to the 1920s this activity expanded and Clifton became a mining village with six coal mines (for further information please consult the Northern Mine Research Society www.nmrs.org.uk). It also had a complicated tramway system taking coal down the hillside to the canal basin and the gasworks on Mill Lane in Brighouse and Low Moor Ironworks. Miners came to live here from other parts of Yorkshire and beyond. The Clifton pits have been closed since around the 1920s, and today all that remains are a series of uneven mounds in Highmoor Lane that carried the tramway tracks and small coal trucks.

Another noted coal mine was at Norwood Green. The Norwood Green Coal Co. sank the first shaft between 1873 and 1876. The company gave up the mine in 1880 and was taken over by the Low Moor Iron Co., who ran it from 1882–87. A second shaft was sunk and was then known as Flather's Pit, which was 115 yards deep. The coal was taken over a series of tramways to the Low Moor Co. Flather's Pit was closed in 1895.

The mine was abandoned until 1930 when Norwood Green Collieries Ltd reopened the shafts. The number of employees working below ground at this time was 142, with a further thirty-three working above ground. When the coal mining industry was nationalised in 1947, the number of men working was 172 below ground and twenty-nine above ground.

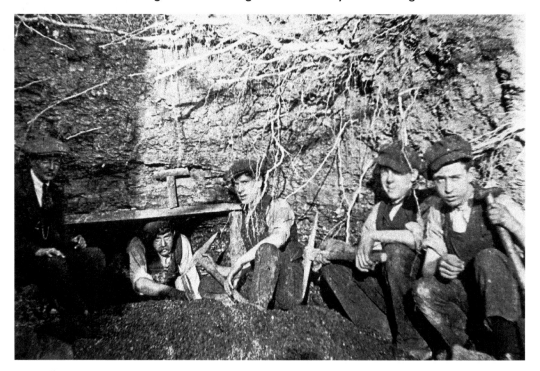

The difficult conditions that Norwood Green miners had to work in at the Norwood Green Colliery.

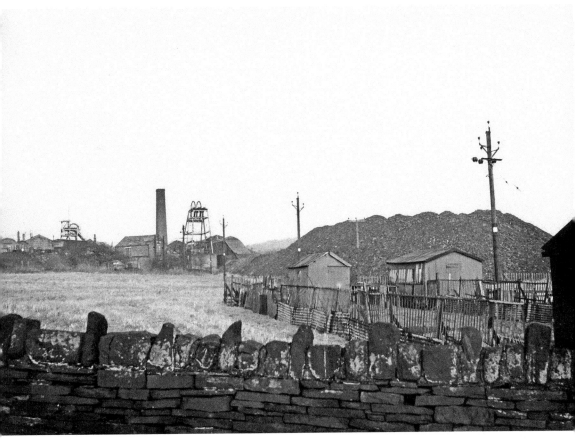

Norwood Green Colliery. This photograph was taken from Station Road, looking across the road from the village war memorial.

It has been reported that this was a 'wet' mine, which caused difficulties for the miners and when notice was given on 12 April 1958 that the pit would close, this was one of the contributing factors. The mine has now gone and been replaced by open views across green fields.

Another coal mine was in the Walterclough Valley, which is situated between Southowram, Hove Edge and Hipperholme. The valley takes its name from Walterclough Hall. The original hall dated back to the fourteenth century. What remained of the hall was demolished in the 1970s; the present-day site forms part of Walterclough Hall Farm.

In 1888, Walterclough Pit – the largest and last coal pit in the area – was opened, but who opened it and who the original owner was remains quite vague. By 1906 the colliery was bought by Brookes' Nonslip Stone to supply both coal and fireclay for its brick works near the nonslip stone plant.

By the 1950s the only part of the Brookes empire remaining was the Lightcliffe complex and from 1960 the company went in to terminal decline. As parts of the company were sold off, what was left – including the mine – was auctioned off on 18 February and 25 July 1969.

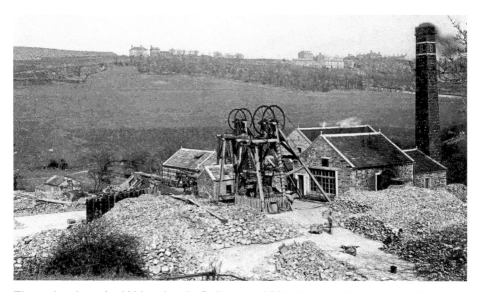

The pithead at the Walterclough Colliery, *c.* 1906. Material from this colliery was transported on a series of overhead cable buckets to the top of the Walterclough Valley. Some readers will remember the sight of the buckets being carried across the valley from the pit. Arriving at the top of the valley, the contents of the buckets were transferred to railway carriages and taken to the main works across Halifax Road by the company's own steam train.

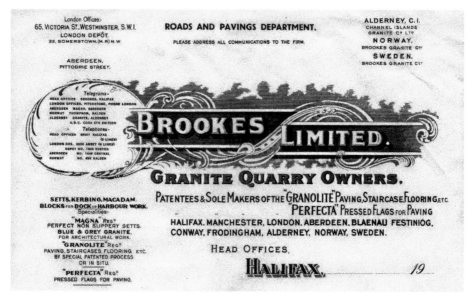

An example of a decorative and informative letterhead used by Brookes Ltd prior to the First World War. Their head office was in Lightcliffe, Halifax, and they had other offices in Alderney in the Channel Islands, Norway, Sweden, Aberdeen, Manchester and in London. At its peak, this company was the largest in the area, employing thousands of people in a number of different parts of the United Kingdom and overseas. Their business empire came to an end in 1969.

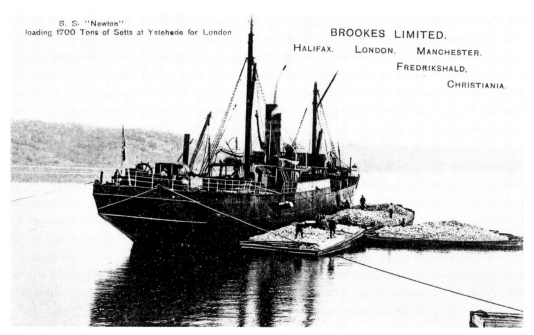

SS *Newton c.* 1910, located in Iddefjorden at Ystehede, Sweden. It is loaded with granite to be shipped to London. Iddefjorden is a long, narrow inlet and runs along the Norwegian-Swedish border. Brookes started its Norwegian business at Fredrikstad in 1902 and sold it in 1929.

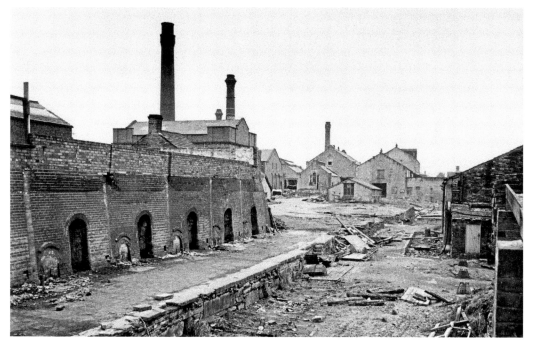

Brookes *c.* 1969. The business has closed down and most of the assets have been sold off. All that remains is the site, waiting to be cleared and redeveloped – a sad end to a business that employed thousands and sold its products all around the world for over a century.

One industry draws to a close in this 1969 image of the towering chimneys at Brookes being demolished. This was in front of not only a large audience on site, but it was also televised on the local news. This action heralded the start of a new industry being built on the site. The site was sold to the international giant Phillips Electronic and Associated Industries Ltd. Once the demolition work was completed and the land had been cleaned, a new washing machine factory was built, which officially opened in the spring of 1971.

The year 1985, following a buyout by David Ross and Derek Clee, saw the birth of a new company on the Phillips site. This new company was named Crosslee – a merging of their two names. The company has gone from strength to strength since its early days. With over 40 per cent of its production being exported to a number of countries – such as Hong Kong, Chile, Vietnam, Paraguay and Kuwait – it was awarded a Queen's Award for Export.

Since David Ross and Derek Clee led the buyout of the Phillips site, the company has produced 12 million tumble dryers – calculated at almost 3,000 a day in the peak season. The White Knight brand now has 25 per cent of the UK tumble dryer market, and has won several awards. Crosslee plc continues to be a major employer in Calderdale — and long may it continue.

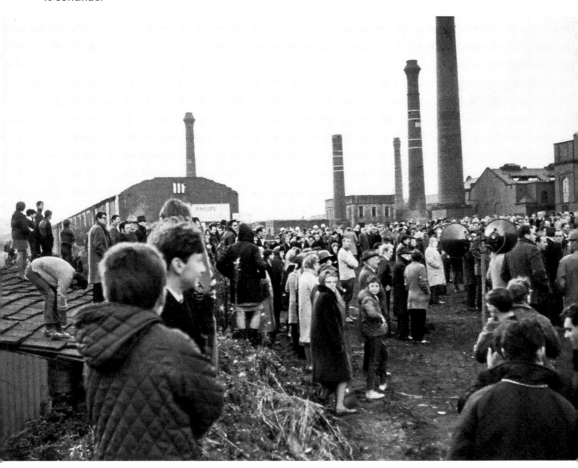

Brookes chimneys being demoilished.

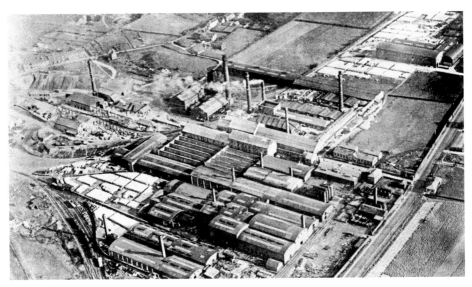

This *c.* 1928 photograph shows just how big the Brookes site was: stretching from Halifax Road in Hipperholme on the right, through to St Giles Road in Hove Edge on the extreme left – a distance of almost a quarter of a mile.

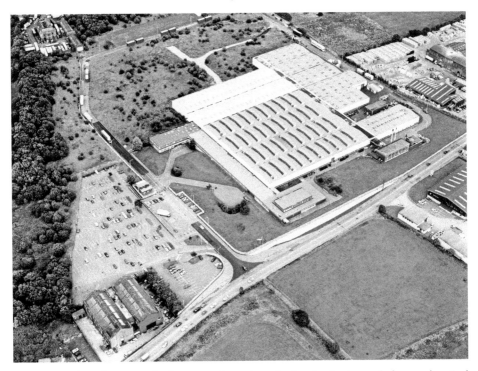

Once the Brookes site had been cleared and the land cleaned from chemical contamination, Phillips UK Ltd built its new, modern twentieth-century factory. This new factory was built on less than half of the original Brookes site.

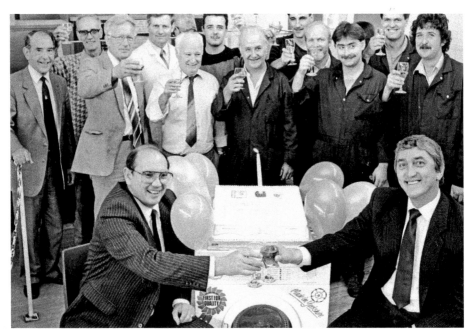

David Ross and Derek Clee celebrate the company's first anniversary with members of staff in June 1987. Crosslee has now grown to be a major company, not only in Brighouse, but around the world.

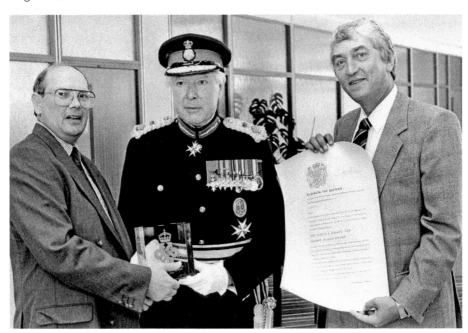

David Ross and Derek Clee receiving the Queen's Award for Export Achievement from the Lord-Lieutenant of West Yorkshire, John Lyles CBE, JP. Crosslee plc now exports 45 per cent of its manufactured goods to Australia, Hong Kong, Malaysia, Singapore, Chile, Argentina, South Africa, Israel and Saudi Arabia and mainland Europe to name but a few.

THE CANAL AND THE RAILWAY

I n the year 1757, an Act was passed to amend the unnavigable parts of the River Calder from Fall Ings Lock at Wakefield to Salterhebble. The engineer appointed to survey the district canal was the Leeds-born John Smeaton, the engineer for the Eddystone lighthouse.

Many problems were identified, particularly with the fall in the river level, and so James Brindley – a working millwright widely acknowledged as the best engineer of the time – was brought in to help. It was Brindley who had constructed the Bridgewater Canal from Liverpool to Manchester. Within two years the 16-mile canal from Wakefield was completed. Brighouse now had its new canal, which gave it an edge over its larger neighbours. It enabled goods to be transported in much larger quantities and far more easily – and at much more competitive rates – to Lancashire and other parts of the West Riding. The local quarry owners in and around Brighouse found this new form of transport a major asset to their businesses. They were now able to deliver much larger quantities of stone, and more often, to even more customers much further afield.

In this 2016 photograph long gone are the days when the bargees would be steering their cargoes of stone, sand, coal and other non-perishable goods from the inland ports (a port on an inland waterway, such as a river, lake or canal that may or may not be connected to the ocean). The two in Brighouse were at Brookfoot and the Brighouse Basin, which was opened in 1768.

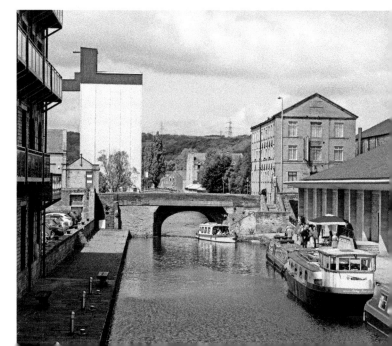

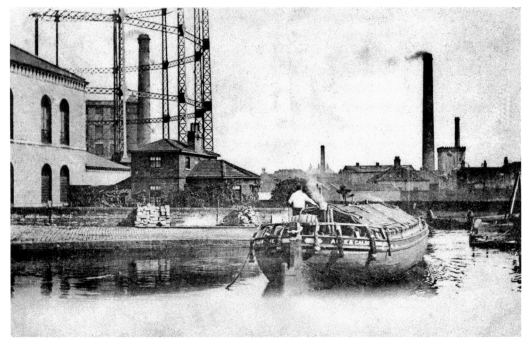

A Calder & Hebble 12-foot-wide working barge passing through the canal basin, c. 1910. Brighouse ceased producing its own gas in 1954 and joined the national grid. This closure brought an end to local gas production after ninety-seven years. Both the gasholder and gas offices on the left were demolished and the site was redeveloped with office buildings.

A downside of the canal's success was the gradual deterioration of the local road network. Following the completion of the Halifax–Wakefield turnpike in 1741 and the Elland–Dewsbury turnpike (via Upper Edge, the top of Rastrick and Fixby) in 1759, it was fifty years before any further major improvements and developments were made.

The canal basin would have been a hive of activity throughout the period, with barges queuing up to be loaded with non-perishable goods. One of the shortest journeys from the basin would have been the delivery of coal to the unloading dock at the side of the Black Swan public house in Briggate (now Millers Bar). The coal was unloaded into a storage warehouse, bagged and then delivered by the Brighouse Co-op coalmen to customers throughout the town and surrounding communities. In the early days, the coalmen would collect and deliver it with the use of horse and carts. These were replaced gradually, over a period of time, by motorised wagons.

The delivery of coal went on well into the mid-twentieth century, when the use of traditional coal for heating began to be used less. One of the reasons for this was the first of the new smoke control orders being submitted by the Borough Council to the Ministry of Health in 1959. This was something Alderman Harry Nobbs JP commented on in his inaugural speech as the new Mayor of Brighouse (1959–60), expressing a hope that the whole of Brighouse would soon follow.

The old Co-op coal depot was eventually demolished and the area is now a picturesque beer garden and children's play area.

Thomas Sugden & Son Ltd's Upper Mill in 1895. This side of the mill overlooks the Calder & Hebble canal, where sacks of flour were lowered down onto the waiting barges. On the opposite side of the mill was Cadger Lane, which was named after the beggars that congregated in the street. It was later renamed Bridge Road. There is evidence that in 1826 Brookes' mill was on or near this site, and that it was a flour and corn mill. It is also documented that in 1842 it was attacked during the Plug Riots. The mill was later occupied by Binns and Berry when part of this Halifax company moved to Brighouse; it became known as the Bridge Road Works. After a number of years, the company returned to Halifax. After two changes of ownership, machines are still manufactured in the name of Binns and Berry in Milnrow, Rochdale.

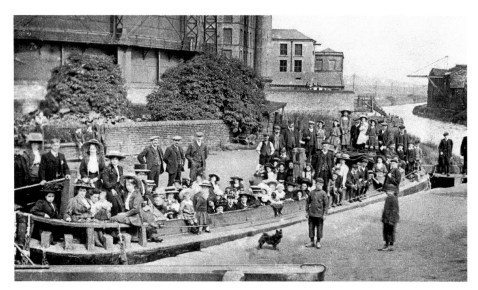

All aboard! This is clearly a canal boat outing for families and, judging from their clothing, they all appear to be wearing their 'Sunday Best'. Leisure trips on the canal were seen regularly, even before the First World War. The Brighouse gasworks was originally built in the Victoria Mills complex in 1844, but a new plant was built in 1857. Note the large gasometer on the left-hand side, which was part of the new plant that supplied gas to the town. Gas production came to an end in 1954 and in later years the site was redeveloped, with it currently being occupied by offices.

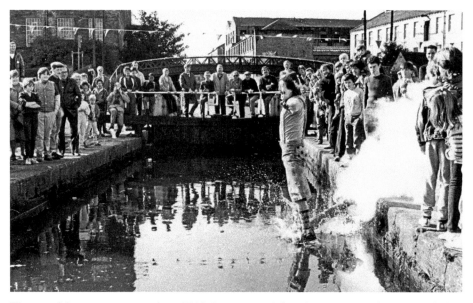

The canal basin was opened in 1768. It was used for the carriage of non-perishable goods to bypass the unnavigable parts of the nearby River Calder. The basin was used by barges delivering coal to the Brighouse gasworks. These days it is used more for leisure purposes, as seen here in 1984 – in the lock is certainly drawing a crowd of spectators.

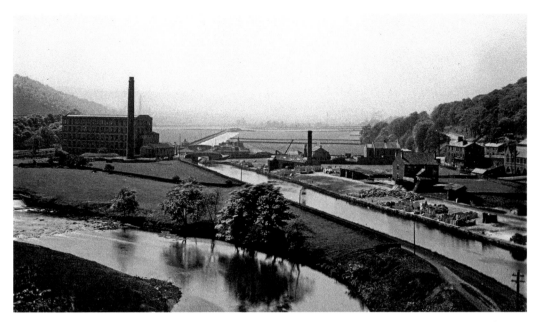

This is Brookfoot, where the winding river and linear canal almost touch each other. On the right-hand side is what was referred to as an inland port. This was where goods such as stone brought from Marshall's Southowram quarries were loaded onto barges. The old mill building is Camm's cotton mill, which was built *c.* 1865. It is still there today and has been occupied by a variety of different businesses over the years.

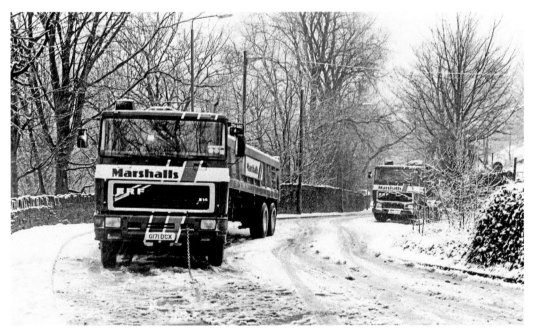

Marshall's don't use canal transport anymore, but these vehicles still have to make the difficult journey up and down Brookfoot Lane to and from the company's works – even in the awful conditions seen here on 3 February 1984.

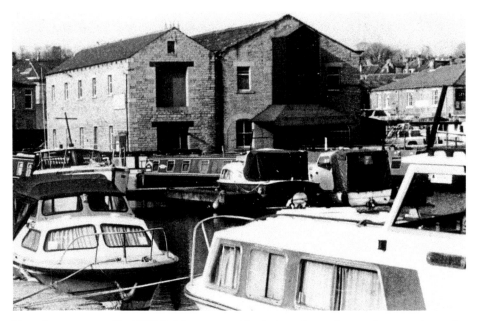

Since it was opened in 1768, Brighouse canal basin has changed over the years. It can be seen here in the 1970s. This building, known as Victoria Works, sits alongside the water's edge, allowing barges used by men known as canal carriers to be loaded from what was called a navigation warehouse. In around 1975 this old warehouse was taken over by Sagar Marine, a canal boatbuilding company started by husband and wife team Stephen and Wendy Sagar.

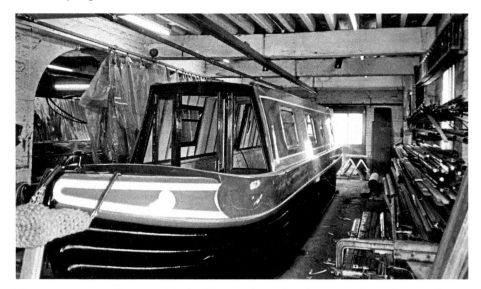

The company initially started by building traditional and semi-traditional narrowboats. Sagar built its first Dutch-style barge in 1991 and introduced its Mini-Luxe in 1993 – a narrow beam designed especially for use on Britain's canals. This family business had a far-reaching reputation for its quality work. Sadly, after almost forty years, this business closed in November 2011. This image was taken inside the boatyard in 1985.

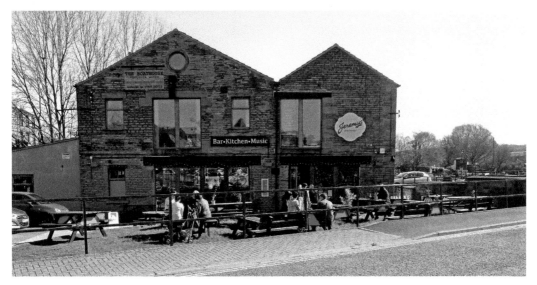

As one business closed down another one was started. Jeremys @ The Boat House is a bar and kitchen eatery in the old Victoria Works. It was opened in 2013 by Rachel Bray and has brought one of the oldest parts of Brighouse to life. Its reputation has grown in the short time since it opened, bringing a renewed vitality and interest in the canal basin area.

The narrowboat workshop, once the home of Sagar Marine, has now gone. It was replaced by a new, innovative eating establishment, where you can look across the canal basin and let your mind wander, imagining the hive of activity it undoubtedly would have been throughout the nineteenth century.

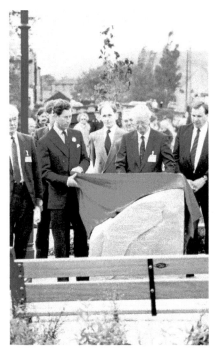

Walking along the canal these days, it is difficult to remember how bad it was underfoot before the new canal-side walk was completed twenty-six years ago. It was HRH Prince Charles who unveiled the plaque, which was set in a large piece of local stone on 12 June 1991.

Like so many other towns in the old West Riding, Brighouse became prosperous when the silk and woollen mills thrived, but, as the industries shrank, it was left with an ugly legacy of dereliction. An end came to that sad state of affairs in the 1990s. The process of rejuvenation owed a great deal to Roy Feather, a retired businessman who neither lived nor came from Brighouse. He is the man standing to the right of Prince Charles in this image.

By the time he was awarded the MBE for his services to the community in the 1994 birthday honours, he had already raised over £50,000 for the canalside walk scheme, which transformed an eyesore to a pleasant area with paved areas, seating, plants, Victorian-style lighting and a car park.

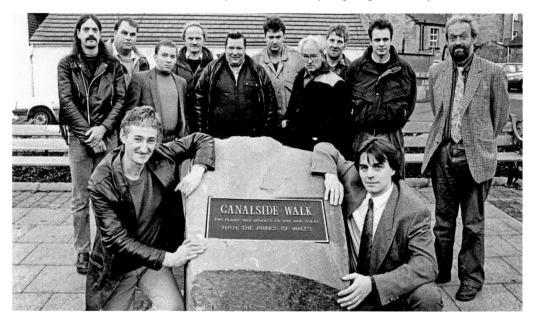

The council matched the funding and improvements were made to parts of the town centre closest to the improved area: the stonework of buildings were cleaned, and shops and banks received facelifts. Roy Feather joined the Calderdale Inheritance Project and the Build a Better Brighouse (3Bs) campaign. He was a founding member of the latter and was instrumental in bringing almost £250,000 into the canalside walk scheme. He was assisted by Bill Terry, who was seconded to the project from industry. Proudly showing the plaque are council officials and some of the men who worked on the project.

In 1830, the barge owners who worked the canal in Brighouse could not have imagined that the dawning of a new era in transport was about to start. The life they had known for the last seventy years was coming to an end. This major change was to bring the dependency on canal transport by businesses practically to an end. Next was the age of the train.

With the successful opening of the Manchester and Liverpool railway in 1830, a decision to connect Manchester with Leeds was proposed, which included the line coming through Brighouse. The work on the new line started in August 1837, with the first section from Hebden Bridge–Normanton opening in October 1840. The first train to reach Brighouse was on 5 October. It was reported in the *Leeds Mercury* newspaper that the line was packed with crowds of people from Brighouse, all watching and staring at what was truly the new wonder of the age.

The new station was built to serve Rastrick, Brighouse and Bradford, and was known as the Brighouse and Bradford station. Interestingly, coaches had to be available at the new Brighouse station to convey passengers to their ultimate destinations of Rastrick, Huddersfield and Bradford. This new service was seen by local businesses as a major boost and enabled Brighouse businesses to dispatch their goods to all of the major industrial areas in the country. The ability to send bulk deliveries at a speed never previously imagined possible was the final death knell of the canals as a commercial transport entity.

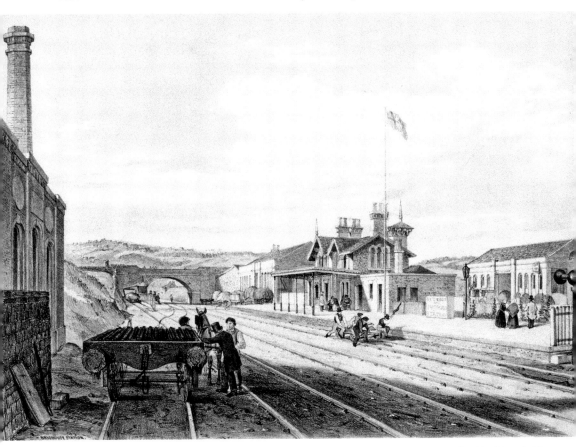

Brighouse and Bradford railway station c. 1845. The bridge in the distance is the Huddersfield Road bridge. Note that the station is on the same side of the road, just as it is today.

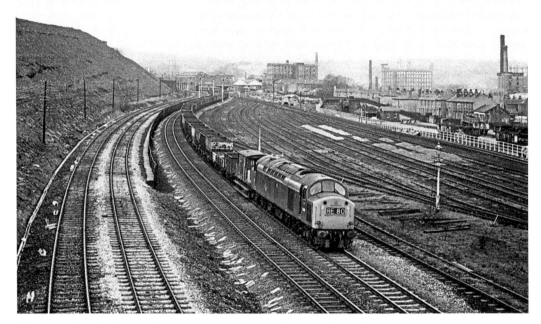

Above: An English Electric Type 4 diesel train travelling east through Brighouse, carrying coal from Lancashire to a power station somewhere in the south of West Yorkshire. It is noticeable that the goods yard tracks appear rusty, which suggests they have not been used for some time, whereas the train tracks are clearly shiny.

Opposite page top: This pre-1946 aerial view shows the extensive good yards on the left that sits alongside the businesses, some of which date back to the 1860s when this area was put up for auction. It is bounded on the right by the canal. The land was sold expressly for the purpose of building mills. In the bottom-left corner, the large detached house was the home of businessman Richard Woodhouse, whose family owned most of the land where Blakeborough's (the newer property) had its Woodhouse works.

Opposite page bottom: Brighouse can rightly claim to have had its first railway station before the city of Bradford in 1840. This station was moved in 1872 to a location across the road. Here we see the very large goods and marshalling yard, which runs alongside Birds Royd Lane. It was this street and the adjacent side streets that housed many of the town's major industries, along with many rows of terraced houses where some of the workers would have lived. The goods yard closed in 1972.

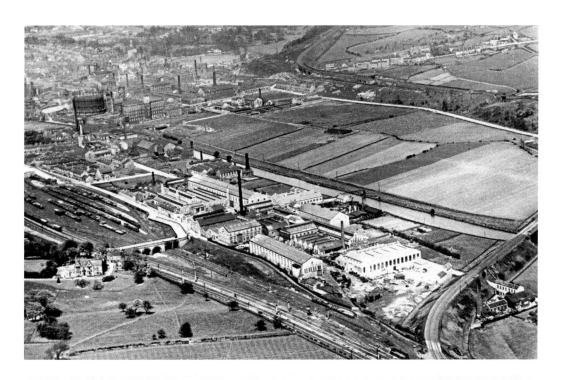

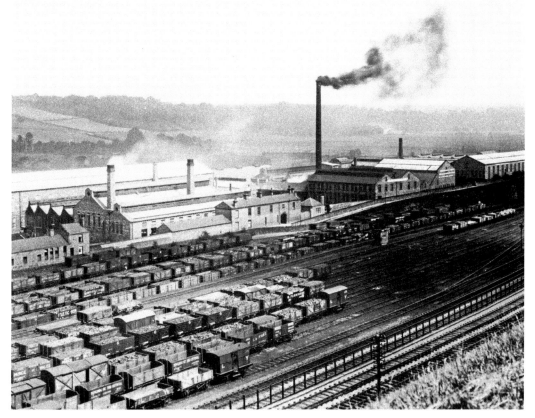

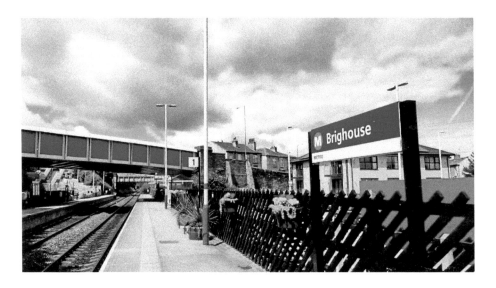

Following the closure of the second Brighouse station on 3 January 1970, many people tried for years to get a new station at Brighouse. On 29 May 2000, the big day finally arrived when a rejuvenated station had its grand opening. Both these images illustrate what a wonderful station it is. A big day that saw many visitors from both the town and railway enthusiasts coming to enjoy the occasion.

It was also a big day for Calderdale Mayor Councillor Graham Hall and his wife Susan. Councillor Hall, who sadly passed away on Saturday 28 January 2017, was a local councillor through and through. He served as the Hipperholme and Lightcliffe ward councillor for eighteen years. He was highly respected for all his efforts in the locality and was very supportive of the efforts to get the station opened. For more information about the station and the work done by the Friends of Brighouse Station please have a look at their website: www.friendsofbrighousestation.org.uk.

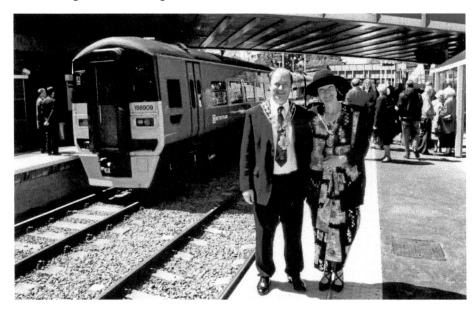

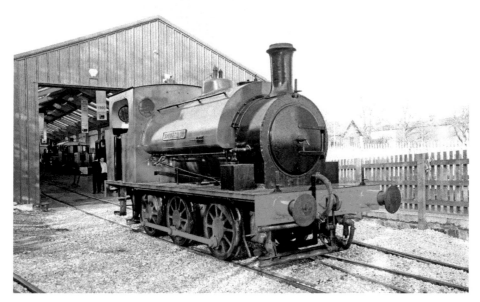

During its long history, Joseph Brooke & Sons Nonslip Stone Ltd at Lightcliffe (1840–1969) had ten steam locomotives. The only one that survives today is *Brookes No. 1*, which was built by Hunslet Engine Co. and dispatched to Brookes in July 1941. Following the closure of the company in 1969, all the remaining railway equipment came up for sale by auction. *Brookes No. 1* was sold for £1,410, although at one stage it was destined for the scrapyard. Today it is delighting visitors both young and old at the Middleton Railway in Leeds.

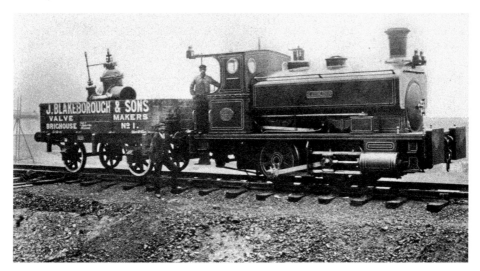

The valve manufacturer J. Blakeborough & Sons Ltd will always have a special place in the industrial history of Brighouse. Here is the company's own saddle tank steam locomotive, *Kathleen*. This engine was named after the wife of Robert Arnold Blakeborough, the company chairman. John Rose is on the footplate, with the shunter being Willie Robertshaw.

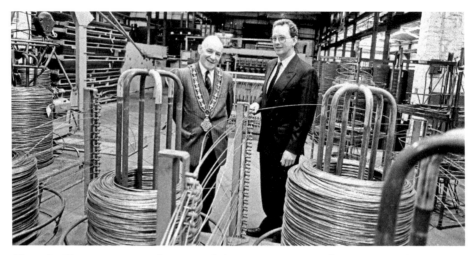

Chris Redfearn, managing director of the company, is in this photograph taken on 11 November 1993 with the Mayor of Calderdale, Councillor Anthony Mazey, who was visiting local industry. The wire picture shows copper flash-coated mild steel being converted into sheets of welded wire mesh.

One of the nineteenth-century wire-drawing businesses in Brighouse was started by Richard Redfearn and Samuel Bedford in 1895; it was based at the Kirklees Ironworks, Mill Lane. The growing success of the business meant a move to larger premises at Calder Wire Works in Foundry Street in 1912. The company was incorporated in January 1928 and its main output was wire for shoe rivets.

The company manufactured a number of specialist wire products, including florist's wire, different-shaped wire (flat, square, oval, half-round), best charcoal iron wire and mild steel wire just to name a few. During the Second World War very large contracts were carried out for the government, especially for work involving aeroplanes, but as soon as the war came to an end the company reverted back to its more familiar specialist wires.

After Reg Redfearn, the great-grandson had completed his war service and had returned to Brighouse he started a new company, Wire Products (Brighouse) Ltd, which was based in Atlas Mill Road and made wire crates for milk bottles and heavy-gauge wire coat hangers. In the 1960s both Redfearn & Bedford and Wire Products (Brighouse) joined Siddall & Hilton to process wire supplied by the Standard Wire Co. in Sowerby Bridge. In 1978, Redfearn & Bedford was absorbed into Wire Products (Brighouse) Ltd. When it outgrew the site on Atlas Mill Road it moved to a new purpose-built factory in Foundry Street, Birds Royd Lane, under the new company title of Redfearn Wire Products. By now the company was market leader in the wire coat hanger market, supplying up to 100 million each year. At this time Sir Herbert Redfearn was chairman of Siddall & Hilton Ltd.

In 1990 the then managing director, Chris Redfearn, installed the first of many huge welding machines to manufacture welded mesh and fencing panels, which, over time, became the new main business. It is still one of the largest wire-product-producing factories in the UK, although, sadly, most of the raw material wire used is now imported. The company name later changed to Siddall & Hilton Products and has remained so following a management buyout from the Sidall & Hilton Group.

At the Foundry Street premises, wire mesh and fencing of the highest quality is still produced to standards that the founding fathers of the company would be very pleased with.

THE WIRE AND LEATHER INDUSTRIES

A long with stone quarrying, two other industries that thrived in the Brighouse area were wire manufacturing and leather tanning. Both can be traced back to the eighteenth century, though it has been recorded that an early stone wire-drawing slab was discovered in Clifton that dated to the seventeenth century. There is no doubt that these two communities were a hub for the wire trade in both wire drawing and card making. By 1830 this trade had grown to considerable proportions, but by the end of the nineteenth century it had gone into decline – though during the 1930s it was a still the fourth-largest industry in the borough of Brighouse.

It has been recorded that Brighouse supplied wire for the Atlantic cable (although I cannot find any additional evidence to support this claim). It has also been documented that a number of Brighouse men went to Pittsburgh, USA, in the 1880s to work in the wire trade, with some of the men being promoted to management positions.

A century ago Brighouse had thirteen companies involved in wire manufacturing and wire products: Thomas Anderson, Calder Vale Mills, River Street; Nortcliffe & Bates' Victoria Works; Calder Street, founded in 1894; Ralph Brearley's Woodland Mills, River Street; George Healey's Low Mill on Wharf Street, founded in 1872; Henry Healey's Livingstone Wire Mill, Wharf Street; Hirst Brothers' Clifton Bridge Mills on Wakefield Road, founded during the 1860s; Joseph Hirst's Kirklees Ironworks, founded in 1887; M. Robinson, Well Street; A. Thornton & Son's Railway Wire Works on Vulcan Street; John Woodhead at No. 27 Elland Road; Redfearn & Bedford's Kirklees Wire Mills, founded in 1896; Ramsden, Camm & Co.'s Leopold Works and wire workers; and J. W. Lister, Police Street, founded in 1889.

Over the course of time many of those companies have faded into the history books, but Brighouse does still have a wire-manufacturing industry. Booth's Wire Products Springvale Works on Elland Road have been manufacturing wire products for over sixty years; Siddall & Hilton Wire Products, which started life as Redfearn & Bedford's Kirklees Wire Mills on Foundry Street in 1898; and J. W. Lister Wireworks, Brooksmouth Mills, Clifton Road has been in Brighouse for over 125 years.

While the long-running Ramsden, Camm & Co. has faded into the history books, this advertisement shows the work it carried out. The company can be traced back to 1840 at the Robin Hood Mill on Clifton Road, and it was still there in 1875. This advertisement is dated 1895 and at that time the company employed 300 workers. As the company grew even bigger it also operated from Leopold Works in George Street off Mill Lane. In 1960, the company was bought out by Spencer's Wires of Wakefield.

The following year, the Leopold Works site was taken over by James Royston & Son Ltd, a company that had a history in wire manufacturing in Halifax dating back to c. 1797. Royston's was itself bought out in 1961 by Hawkins and Tipson, a rope manufacturers. In 1964, this company took over another of the long-established wire works in Brighouse's Nortcliffe and Bates, then, in 1966, it took over another of the well-established manufacturers, George Healey & Sons. In 1980, Hawkins and Tipson moved and the Brighouse site was closed.

Following demolition of the old Leopold Works, new factory premises were built on the site, which is now occupied by Dyson Energy Services Ltd. In 2016, this company became part of the Liverpool-based Duality Group.

This advertisement for Ramsden, Camm & Co. from 1895 gives an illustration of their product range. With a customer base that extended across Europe and North America, Brighouse was a true exporter of both goods and services.

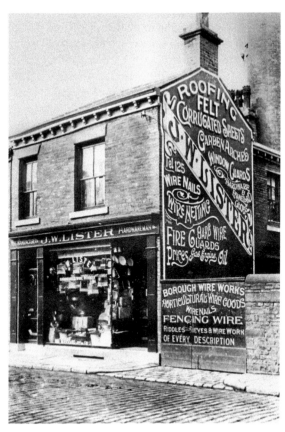

Left: John William Lister.

Right: J.W. Lister's ironmongers and hardware shop at No. 9 Police Street, Brighouse.

The founder John William Lister was apprenticed at a wire works in Brighouse. In 1889, he established his own business at Little John Mill and within five years he opened a shop at No. 9 Police Street (now Lawson Road) selling ironmongery and hardware. He was well into his seventies at the time. The company was still growing when he took over Brooksmouth Mill in the Clifton Road, premises where the company still operates from today.

Brooksmouth Mills was occupied by John Wilson Armitage & Sons as a silk spinners. The company started life as Baldwin, Armitage & Co. in 1882. When the partnership was dissolved, Armitage established his business in his own name. Brooksmouth Mill was described in 1895 as a three-storey building that was well situated in the town. The company introduced all the latest machinery for the delicate work in silk. The company operated 1,400 spindles along with the dressing and silk preparation requirements. One of the businesses principal customers was in Nottingham, with overseas customers in both France and America. As the company grew, John Wilson Armitage introduced his two sons Herbert and Ernest into the business.

The mill was later occupied by A. Rawlinson & Son, silk spinners. This company was operating 1,400 spindles and employed forty-five workers. It was in 1895 that John William Lister started his business in the mill – the building was in the ownership of T. B. Sugden at the time.

John William Lister was born at Cock Walk Farm in Clifton. He was a founding member of Clifton Band, and a member of Clifton Church and its choir. He was also a member of the Clifton handbell ringers and was the vice president of the St Andrew's Bible Class for twenty years. He died at his home in Lightcliffe Road in 1939 with the knowledge that his family business was in safe hands.

Throughout the history of J. W. Lister's wirework business, the company has been able to adapt to the times. From initially manufacturing wire netting, fire guards, wire fencing and wire nails, the company diversified into the manufacture of floral tribute frames. This was at a time when all the joints were knotted – the old-fashioned way – unlike today, which are spot welded.

During the 1960s once again the company changed direction and began to successfully manufacture laying cages for the egg production industry. This new aspect of the business expanded into exporting the flat packed cages to Nigeria, Sweden, Canada and USA. In those days orders had to be delivered to the goods yard at Brighouse railway station for delivery. These would be loaded on to a car driven trailer by the owner of the company and delivered by him personally to the station. However, in time with growth in free range egg production it was time for the company to look again to the future.

J. W. Lister's wire workers, Brooksmouth Mills, Clifton Road, Brighouse.

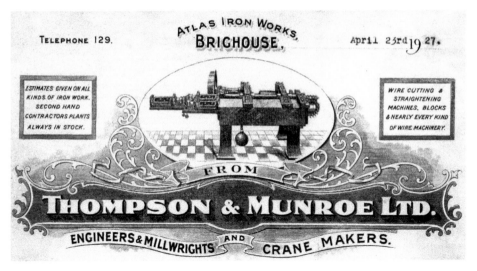

An example of a letterhead of Thompson and Munroe from 1927.

Another company linked to the wire industry is Thompson & Munroe from Atlas Mill Road, Brighouse. This company also has connections to the stone trade as Joe Thompson, the founder of the company, worked in the Southowram Quarry, which was owned by his father. From being a quarry worker Joe went to work for Alfred Robinson, who had an established business at Victoria Iron Works manufacturing machines for the wire industry.

At the age of twenty-eight Joe went into business for himself. One of his first designs was for a crane made of iron and steel, which was to be an improvement of the wooden ones that were in common use at the time – particularly in the quarries. After a few years working on his own, he went into partnership with John Willie Walton at a small works in Elland. Most of their customers were local quarry and monumental masons. At the end of the First World War Joe was back working on his own and went into a new line, a wire-straightening and cutting machine. The business was thriving and most of his early customers came from the industrial areas of Birmingham and Sheffield.

In 1926, the year of the General Strike, Joe joined forces with Philip Munroe, a designer by trade. The company then operated under the name of Thompson & Munroe Ltd and between them they designed the first high-speed wire-straightening and cutting machine. So successful was the company that by the end of the Second World War the company had a two-year order book.

In 1922, George Thompson, Joe's son, joined the company and, following Philip Munroe's death, George became a partner. Following Joe's retirement he became the sole owner. In 1967, following the family tradition, Joe's grandson Paul joined the company. In 1988, the company merged with Hudson Forge Ltd and continued as a successful wire-straightening and cutting-machine-manufacturing company in Brighouse, trading as Thompson & Hudson Wire Machinery. Today the company is truly global, with customers in Germany, USA, Iceland, India and China, as well as its home markets in the UK.

The company has come a long way from the days when the high-speed straightening and cutting machine was demonstrated at many of the leading wire manufacturers by Joe Thompson, travelling from one company to another. For these demonstrations the machine was installed inside the back of an old taxi and then driven from the drive shaft. The demonstrated machine with the taxi was eventually taken and sold to a company in Warrington, with Joe having to return to Brighouse by train.

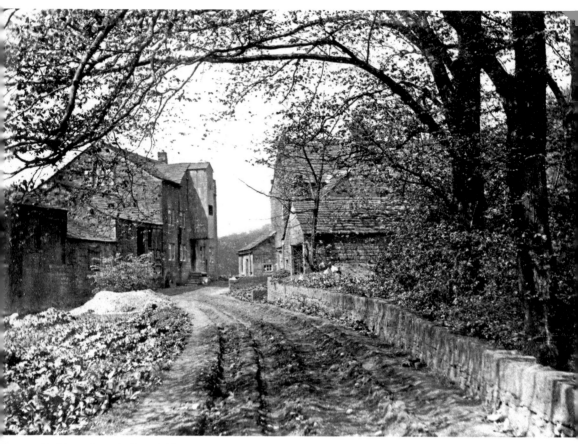

Kirklees Corn Mill, *c.* 1900.

The leather trade seems small in comparison to many of the other larger industries in Brighouse; however, there have been two principal leather companies Fairburn's in Brighouse and James Lee at Hipperholme that became well-established businesses.

The Fairburn family were principally card makers, a business that was established by Adam Fairburn in 1770. His grandson, Edward Fairburn, who was just eight years old when his father Charles died in 1827, started to take an active interest in the company by the time he was fourteen. In 1850 he took over the Kirklees Cornmill at Cooper Bridge and, in time, introduced his own two sons, Edward and John, into the business.

In 1878, the business was expanding sufficiently enough that they were able to purchase part of the Victoria Works in River Street (Birds Royd Lane) and, in 1890, the nearby Calder Vale Mills. In 1894, the Fairburn family fenced these two sites off and changed them into leather works.

The Calder Vale Mill was turned into the tannery with scouring rooms, drying sheds, rolling and currying rooms, warehousing and large making rooms. Their business quickly established itself and even won gold medals and certificates at an exhibition held in Huddersfield for their speciality work in leather belting (machine belts).

In the Victoria Works, separated only by a small field, there was initially a wire drawing and card clothing business. In these premises they had drawing rooms, annealing and cleaning sheds, hardening and tempering rooms and all the latest heavy machinery that the industry offered for this type of business.

The finished goods utilised all the skills of their workforce and ensured their products were sold all over the north of England and many other parts of the country; the name of Brighouse was well to the forefront of this kind of industry.

With growing success at both Victoria Works and the Calder Vale Mills, the Fairburns decided to sublet the Kirklees corn mill to Henry Dean for the remaining period of their lease. After the expiration of the lease, Henry Dean signed a new one with Sir George Armytage to rent the whole of the corn mill site for £111 per year.

The corn mill kept on working until 1946, when its working life came to end. The Dean family continued to live on the site until the 1980s. With the passage of time the whole place fell into a state of disrepair, which resulted in the surrounding woodland almost reclaiming it. In 1985, work was started to turn Kirklees corn mill into a pub and restaurant. This was completed in 1988.

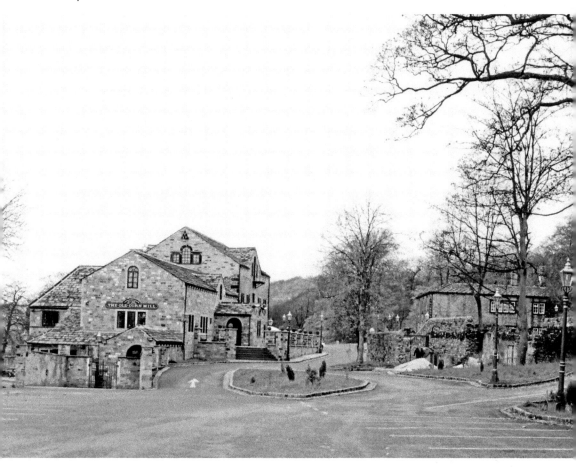

The refurbished mill is now known as the Old Mill and is part of the Chef & Brewer chain of hostelries. The inside of the premises have been retained with its warren of rooms, with some of them still having views overlooking the Calder & Hebble navigation canal.

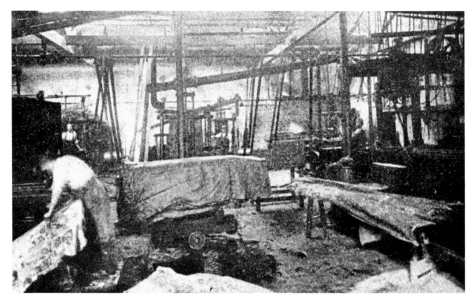

Having added Kirklees Mill to their works in 1850, in 1878 the company purchased part of Victoria Works in River Street (Birds Royd Lane), Rastrick. Then, in 1890, further expansion saw the company take on the additional adjoining Calder Vale Mills. This *c.* 1895 photograph shows one of the workrooms in the mill. In 1894, these two premises were enclosed as one and converted into a leather works.

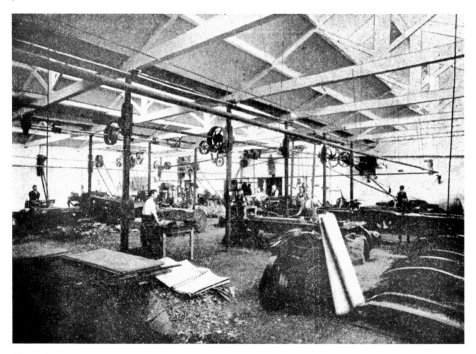

This photograph was taken inside Calder Vale Mill's cutting shed *c.* 1895. The mill comprised of a tannery, scouring room, drying shed, rolling and currying rooms, warehousing and a large room for making belting and other mechanical leathers.

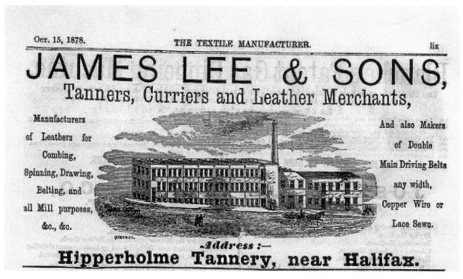

At the Crow Nest Estate in Lightcliffe there was a property and land auction in 1867; James Lee of Hipperholme purchased Lots 45, 46 and 47, which were known as Tan House Croft. It was here that he built a new tannery building, which, by 1894, was employing sixty people. It was this tannery that gave the neighbouring street its name of Tanhouse Hill. The Lee family ran the tannery business on this site until 1903, when it was sold to Brookes, the stone company. The Lee family continued in this trade at their new premises in Gardener's Square, off Denholmegate Road in Hipperholme for a number of years.

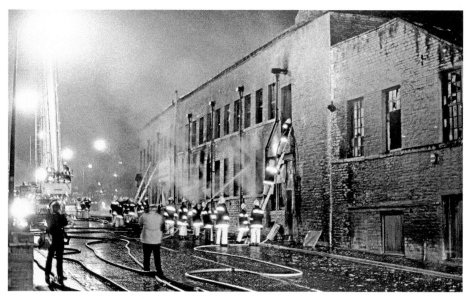

The old tannery mill building was destroyed by a huge fire on 16 October 1990. It was then used by the Hipperholme Camping Centre. The burned-out remains of the mill were later demolished and redeveloped – the camp centre moved in on its completion. Today the property is occupied by Paw Prints, a thriving business that can supply anything pet-related – from pets themselves to their creature comforts.

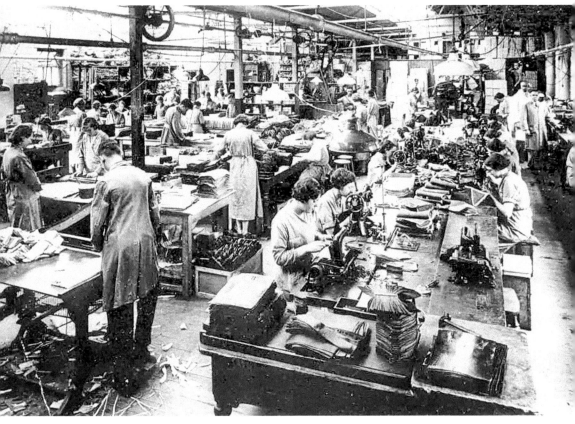

Bustling activity at Sharpe's.

Prior to the Second World War the manufacture of premium leather handbags, wallets and purses were principally made in Germany and Austria. However, with the outbreak of the war, opportunities came for other companies to step in and fill in the gap in the market. It was William Sharpe who, with the use of the very latest machinery and equipment, was one of the companies that was able to step in and start his business in high-quality leather goods. He extended his product range to include wallets, pocketbook cases, school bags, and music and attaché cases. Such was the success of his company that he regularly received orders from throughout the United Kingdom and the Commonwealth countries.

Some readers may remember Sharpe's leather works, which was based in Park Row opposite the Brighouse Rest Centre in the town centre. Gone are the days when this 1930s town centre business was a hive of activity – as it is in this image. Following its closure, the property has housed many different businesses, which included a wartime British restaurant. A number of businesses occupy the property today, which is still just a short walk from this quiet backstreet to the hustle and bustle of the town centre.

There were a number of other smaller leather works in and around Brighouse, which included Brighouse Leather in Water Street, who manufactured everything from leather hydraulic seals to dog collars, and Wilson & Co., leather belt manufacturers at Bailiff Bridge.

While the leather industry has been one the oldest in and around Brighouse, sadly it has now faded into the mists of time. It was a significant employer in the town and had customers around the world.

THE SILK TRADE

This aerial view shows Bradford Road to the north, and Huddersfield Road to the south. The large mill complex to the right-hand side in the centre of the photograph was known as 'The Square', a name that can be attributed to Samuel Baines, the nineteenth-century industrial entrepreneur. The Square was a hive of industrial mill buildings, which, at its peak, employed thousands of people from Brighouse, its wider community, and workers from many of the neighbouring towns. The first mill on this site was built in 1837, with others soon following. The whole site was finally demolished in the late 1980s to make way for the town's new Sainsbury's supermarket.

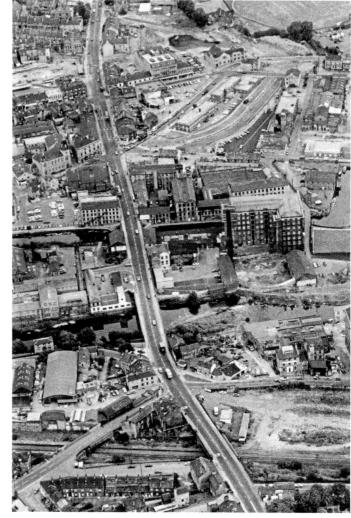

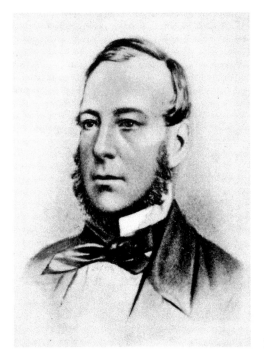

Samuel Baines.

James and Henry Noble built the Victoria Mill in 1837 on a plot of land they purchased from John Bottomley, a noted worthy of Brighouse. In 1842 Revd Benjamin Firth, a Clifton minister and a tenant at the mill, bought it outright. He was also responsible for the Prince Albert Mill and the Canal Mill, which were built alongside the canal towpath and Huddersfield Road with the entrance to the mill's yard facing Huddersfield Road.

During the period prior to the erection of the Brighouse Gasworks in Mill Lane Revd, Firth had a small gas plant at Victoria Mills. In the later part of 1843 the first three gas lamps in the town were erected and illuminated on 31 December 1843.

In July 1849 the nineteenth-century entrepreneur Samuel Baines bought the whole site. He went on to buy additional land from Sir George Armytage, Kirklees Hall. He built Britannia Mill and other smaller buildings on the site in Mill Lane and Wharf Street, along with two imposing dwelling houses facing Huddersfield Road, which were later converted into a branch of the Joint Stock Bank offices. He also built some cottages in Mill Lane known as Baines Row, although these were of a very poor standard of housing compared to those of today. These terraced properties were the homes of many families who were all employed in the nearby mills he had developed and built on the site.

Some readers may remember the last vestiges of Baines Row, which was demolished as part of the Sainsbury's supermarket development in 1990. It was the former offices of Brighouse solicitor Charles Hinchliffe. Readers may recall that these offices had an archway leading through to the rear of the premises, in the centre of the arch was the date '1852' and the initials 'S.B.' – the initials of Samuel Baines.

Victoria Mills had no fewer than twenty major businesses operating on this site, with a number of different manufacturing processes in operation at any one time from the 1830s through to the First World War. It was Samuel Baines who encouraged Burrows and Monk to move their silk business to the site in 1850, and, ten years later, encouraged J. & H. Stott to keep their cotton business going, which employed over 150 in the Square.

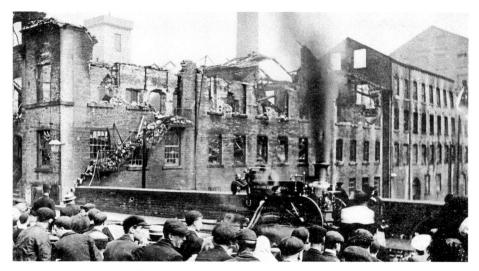

The Victoria Mills fire of July 1905. This was just one of three large-scale fires during its history – the first was in 1872 and the last in 1959. While this was a devastating fire, with many local people being made redundant, a large section of the complex was saved. Although reduced in size, some work at the mill did continue but on a much smaller scale, though some parts of the mill complex inevitably had to be demolished.

Samuel Baines was also responsible for introducing the first fire engine to the town, *Neptune*. His private fire volunteers not only dealt with fires at Victoria Mills but were also available to deal with fires in other parts of the town as well. Samuel Baines died on 25 July 1866, and, like his father, he was an industrial pioneer and largely responsible for helping to spread the name of Brighouse far and wide.

Two other families whose names would become giants in the early cotton industry initially at Victoria Mills would be Blackburn and Stott families. The Square gradually employed hundreds of people from in and around Brighouse. By 1900 many of the familiar names operating in the Square had moved on to bigger and more up-to-date mills elsewhere in the town. The existing mill buildings were soon occupied with other businesses, including Wilkinson & Airey (silk, Victoria Mill), Haley & Wadsworth (cotton spinners and doublers, Britannia Mill on Wharf Street), A. Robinson (engineer, millwright and machine maker, Victoria Iron Works), W. H. C. Hoyle (cotton doublers, Victoria Mills), William Ratcliffe (cotton doublers, Victoria Mills), and C. Sutcliffe & Son (cotton doublers, Victoria Mill).

It was the growing cotton and silk industries in Brighouse that created even more work and jobs for people – not only from Brighouse but for other neighbouring towns as well. These giant mills would often employ three generations from the same family – children, parents and grandparents. As the town prospered and other businesses began to grow during the mid-nineteenth century, many of them moved into the Victoria Mills complex. Some of these included Robert Newton and James Burrows, who introduced the silk industry into Brighouse in 1843. Their partnership was dissolved in 1845 and for a short time Burrows left the district, but returned to start a silk waste dresser business in Thornhill Briggs Mill. In the meantime, Robert Newton remained at Victoria Mills until 1848, which then gave James Burrows the opportunity to return and commence his new business partnership under the title of Burrows & Monk. It was this partnership that started a new aspect of the silk industry by introducing silk spinning at the Prince Albert Mill.

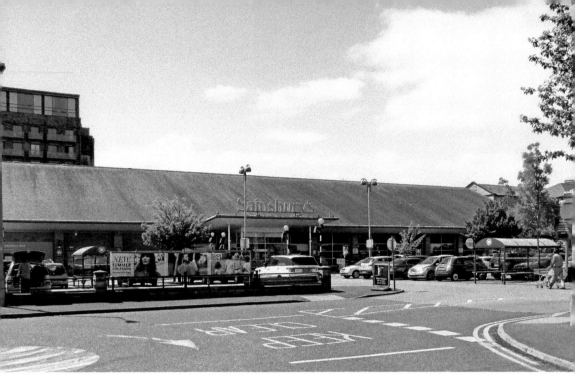

The Sainsbury's supermarket was built on the site of the Victoria Mill complex in 1990. Mill Royd Island apartments overlooking the supermarket were converted from the old Mill Royd cotton mill in 2003.

The cotton industry was making rapid progress at this time and by 1859 two new mills were built, with the owners Jonathan and Henry Stott employing around 150 employees at Victoria Mill. This industry was beginning to employ as many as the silk industry.

Many will ask: 'How does Brighouse, a West Riding mill town, have such a history in the silk industry?' There is some doubt as to the exact year, but in c. 1830 Robert Newton moved to Brighouse from Lancaster. A man of enterprise, it was through him directly that the Brighouse Mechanics' Institute was formed in 1846. He started spinning silk in a small way in premises adjacent to the River Calder. This was a virtually new industry, but it was not long after that he was joined by Burrows & Monk, who also came from Lancaster, Bottomley J. Fearnley & Co., Noble & Sugden, and Samuel Baines, who at various times all had premises in Victoria Mills.

A turning point for this industry was the Franco-German War of 1870/71, which resulted in the French silk industry practically coming to a halt. With a small silk industry already having being established, the war gave increased opportunities to the Brighouse silk spinners. Other firms were soon established both in Victoria Mills and other areas around the canal and river: Wilkinson & Airey (Victoria Mills); Noble (Spring Bank Mill); Stott Sons & Sugden (Owler Ings Mill); Inman Newton, Wrigley & Binns (Birds Royd); Baldwin & Armitage (Spring Bank Mill); Barker & Butterworth (Belle Vue Mill); Wood Bros & Hill (Brooksmouth Mill); Wood Bros & Sons (Thornhill Briggs Mill); Wood, Robinson & Co. (Wilkinroyd Mills); J. Baldwin & Sons (Ganny Mill) and T. Binns & Co. (Clifton Bridge Mill). These mills were able to provide employment to generations of local people.

The largest silk businesses were Richard Kershaw & Sons (Woodvale Mills) and Charles Jones Ormerod & Sons, who later took over Woodvale Mills, and John Cheetham & Sons (Calder Bank Mills). The Brighouse silk industry has now also faded into the mists of time, but many readers will recall the halcyon days of the many silk mills that once towered along the Brighouse skyline.

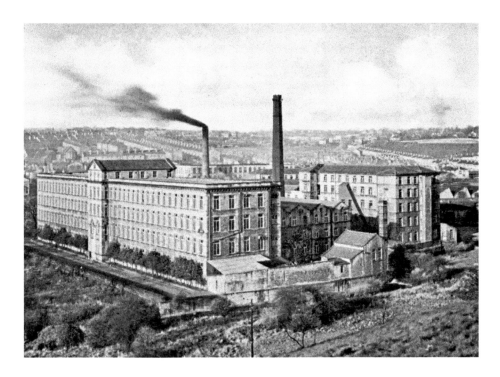

The Brighouse architect George Hepworth was commissioned to draw up plans for the new silk mill on the Wellholme Park estate by Richard Kershaw. It was to be the largest silk mill in Brighouse and dwarfed all those at Victoria Mills. The new mill was called Woodvale Mills and was opened on 29 April 1882. At its peak it employed 600 people and ran 40,000 spindles. In 1903, the mills were bought by Ormerod Bros Ltd. This company expanded into spinning from wool and worsted, nylon, rayon and various fibres and hairs. In 1984 the mills closed down, and the following year they were almost destroyed by fire. They were demolished in 1986. Today the two remaining buildings form part of the Woodvale Business Park.

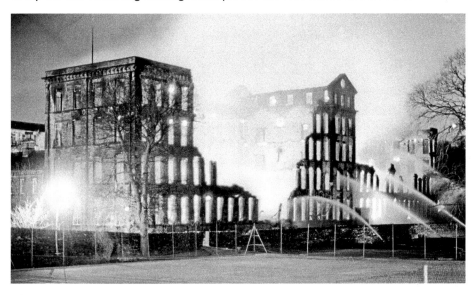

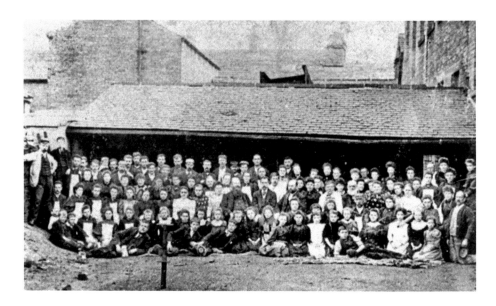

The above photograph, dated *c.* 1891, shows some of the workers outside Phoenix Mill, which was owned by Leeds-born cotton spinner Thomas Blackburn, and was built in 1841. As the business grew he extended his business empire by building two more mill properties: Atlas Mill and Broadholme Mill – both situated in Atlas Mill Road. The company occupying the mill during the period this photograph was taken was Richard John Ferguson, silk manufacturer and broker.

In 2002, the remaining part of these mill premises was purchased by the Artisan Fireplace by Design Co. This is now Europe's largest heating centre of excellence. The owners of this company have an appreciation of the building's past and have kept some of the features that would have been familiar to the workers a century earlier.

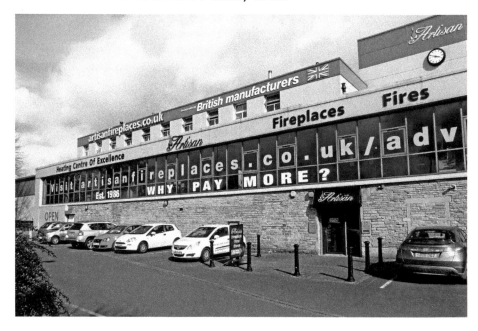

COTTON, WOOLLEN AND WORSTED TRADES

Brighouse Lower Mill was sold at public auction by Sir George Armytage Bart in 1816 at what was the most important land sale to take place in Brighouse. He was paid £4,500 by the Calder & Hebble Navigation Co. for the mills. The sale catalogue describes the property as 'Fulling and Scibbling Mills' and as being equipped with three waterwheels; seven doubling fulling stocks; one single and three double drivers; and, for the purpose of fulling cloth, also 70 inches of card for scribbling and carding wool, and eight blocks of working wire. In addition there was a cottage, a house, mill yard, garth, the little close and part of the Mill Royd.

Scribbling – otherwise known as carding – involved the taking of a lock of wool and running it across some form of sorting device to remove tangles and debris, and get the fibre going in the same direction. In practice it is a little harder than that. Fulling is a step in woollen-cloth making that involves cleansing the cloth to eliminate oils, dirt and other impurities; it also makes it thicker. The worker who does the job is the fuller, tucker or walker – names that have become common surnames.

The cotton industry did not exist at the beginning of the nineteenth century, but within fifty years it was one of the largest employers in Brighouse and its surrounding districts. Several new mills were built or extended for this booming industry: Atlas, Alexandra, Woodvale, Victoria, Mill Royd, Calder Bridge, Calder Bank, Broadholme, Phoenix and Brookfoot. These were just the largest of the mills; there were many others occupying smaller premises.

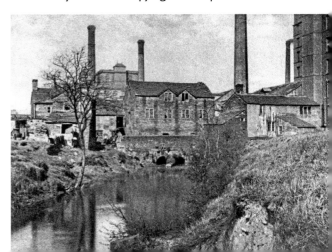

This view of one of the oldest manufacturing mills in Brighouse is dated 1885. The mill was known as Brighouse Lower Mill. The location is given away by the gable end of the large mill on the right-hand side, which today forms part of the Mill Royd Island apartment property on Huddersfield Road.

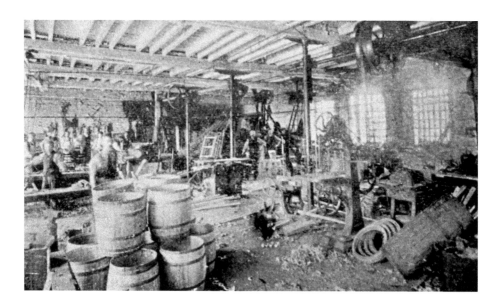

Little John Mill, one of the oldest mills in Brighouse, is situated at the corner of Clifton Road and Oakhill Road. During its long history this mill has been used by a number of different industries. It was built in 1785 as a two-storey fulling, scribbling and carding mill by John Clegg and was known locally at the time as Clegg's Mill. It was built on land called Ganger Ing. The mill wheel was driven by the Clifton Beck. During the early nineteenth century it was used for some time as a corn mill by Samuel Pollard. The next occupants to use the mill arrived in 1828: Samuel and Frederick Pitchforth, who used it for wire drawing. An extra storey was added around then too. This was followed by Robert Newton and James Burrow. It was their silk business that helped to start an industry that would grow enormously in the town and would eventually employ hundreds of local people. The above photograph was taken inside the mill in 1895 when it was occupied by James Dilly, cabinet maker, cooper, wood turner, and manufacturer of barrels and tubs. Today the mill building is subdivided for a diverse use by a variety of different businesses.

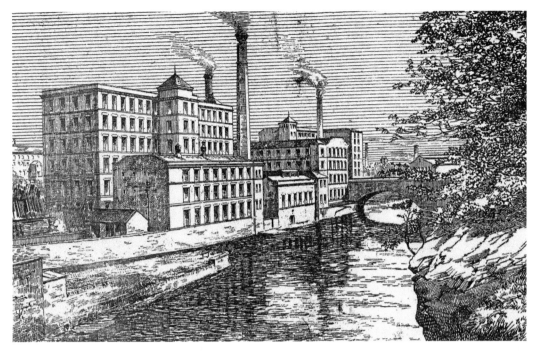

The Alexandra Mill.

The Alexandra Mill shown in this late nineteenth-century illustration stood alongside the River Calder on the north side and faced Millroyd Street on the south side. It was built in 1872, when the silk industry was beginning to be a major employer in Brighouse. The company was known as Ormerod Brothers and Cheetham. The foundation stone was laid on 13 September 1871 by local architect George Hepworth. For over thirty years this mill employed over 400 people – often three generations from the same family. Some twenty years before that the Prince of Wales Mill was built in Birds Royd Lane as a cotton spinners for Messrs R. Kershaw & Co., but later became part of the Ormerod Brothers and Cheetham business. In 1881 John Cheetham retired from the partnership, leaving both mills in the hands of Charles Jones Ormerod and his brother Hanson Ormerod Jr. John Cheetham, although retired, built a new mill of his own at Calder Bank at the junction with Birds Royd Lane. This mill was destroyed by a huge fire on 10 March 1904.

Alexandra Mill was six storeys high and measured 50 yards by 60 yards and, along with the Prince of Wales Mill, employed several hundred people. When both mills were running to capacity, the company was recognised as one of the largest employers in the town.

It was on 26 October 1903 when the old Alexandra Mill, which at that time was still referred to by many employees as the 'new mill', broke for dinner at the usual time. With just a few minutes left before everyone was due to return to work, the chatter among workmates was suddenly shattered by the ear-piercing sound of the fire alarm. This part of Brighouse was densely populated and once the siren was heard everyone was out looking for the plumes of smoke and trying to work out which mill it was this time.

A mill owner's nightmare was fire and, of course, with each mill employing hundreds of people, if a mill did catch fire, the fire brigade, while doing its best, could do little to save it before being completely lost. These losses inevitably put everyone out of work and whenever the siren was heard people were naturally anxious for their family's future.

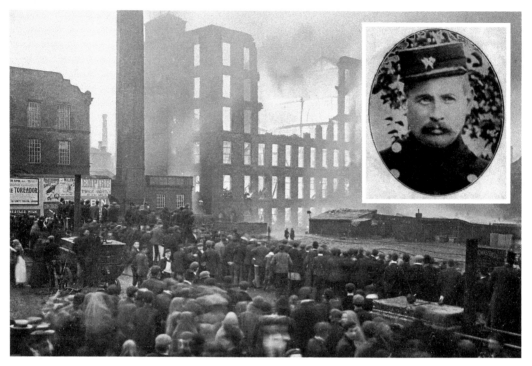

Fire damage. *Inset:* Firefighter Alexander Carmichael, who tragically died when he was thrown from the fire appliance while it was en route.

It seemed that within no time at all six fire brigades had arrived at the scene and were pouring water into the doomed building. The fire was very quickly out of control, leaving the firefighters with little to do but try and prevent it from jumping across to other buildings. As the building was engulfed by fire it soon began to fall apart.

The mill was completely destroyed, leaving an estimated loss of £40,000 and 400 people without work. The fire is reputed to have started in the rope race, which caused friction as it slipped through the flywheel. This ran through a vertical shaft from the top floor to the ground level. Although it was known to have been a problem before the fire, it was initially overlooked – once the fire caught hold, the mill was doomed.

Local fire chief Superintendent Gaudin and some of his staff had already noticed the smoke hovering over the town. He soon arrived at the fire station and, as the remainder of his staff arrived, they made hurried preparations. One of the first firefighters to arrive was Alexander Carmichael, who had been a firefighter for many years and would have attended a number of these large mill fires before. It was reported later that he and his wife had just finished their dinner at their Commercial Street home, when he heard the fire alarm as he was walking back to his labouring job at Woodhouse & Mitchell.

As the Brighouse fire engine gathered speed down Halifax Road and then on to Commercial Street, one of its wheels hit a raised road sett, which resulted in fifty-one-year-old Alexander Carmichael being thrown out and into the road. The attending doctor reported that his death would have been instantaneous. He was the first Brighouse borough firefighter to have died while on active service. His was the largest funeral ever to be seen in Brighouse at the time. The crowds lined the streets from the town centre all the way to his final resting place at the Brighouse cemetery. Although hailed as a local hero, there is still no headstone marking the site of his grave.

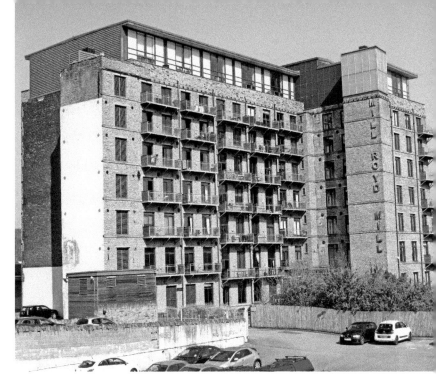

The Mill Royd Island apartments. The developers reported 100 of the new apartments had been sold within days of being advertised for sale.

Jonathan and Henry Stott who were cousins from Ripponden, started a cotton spinning business in part of the Victoria Mills in 1857. By 1861 this company was employing 150 local people. As the business expanded they moved into Mill Royd Mill, one of the largest mills in Brighouse, which had become known in the town as 'Stott's Mill'. After the death of Jonathan Stott in 1871 it was run by his son James Maude Stott and his uncle Henry.

James Maude Stott died in 1875 and Henry brought his son-in-law John Lister into the business. By 1888, having been in the hands of trustees, the company was taken over by John Lister's sons, Thomas Edward and Herbert Jonathan Lister. Even with the change of management, the business retained the name of Jonathan Stott.

This seven-storey mill ranked alongside Alexandra Mill as one of the largest in Brighouse, measuring 150 yards long and 21 yards wide. It and needed 600 hp to drive the plant and operated 50,000 spindles, employing over 300 Brighouse workers. With customers both home and abroad, the mill operated at full capacity all the time. The mill had a chequered history, having had two major fires. The first was on 12 November 1868, causing damage estimated at £12,000, but the second fire on 17 February 1874 completely destroyed the mill, which resulted in a new one having to be built. However there was a problem at the new mill that was the cause of yet another fire, in 1878. The ground where the front end of the building stood (to the left of the above mill) was found to contain quicksand. This caused the centre of the mill to have settlement in its foundations. The outcome was friction in the main shaft, which ultimately resulted in another fire. Even after the fire was put out it was discovered the land was still unstable and the decision was taken to demolish that end of the mill (Huddersfield Road end) and not to replace it.

Having had many ups and downs with the industry's changing fortunes, for many years the mill was occupied by Henry Cullingworth and known locally as 'Cullingworth's Mill'. In 2003 it was bought by Richard Binks of Binks Vertical property developers. When sales opened, 100 of the new apartments were sold within four hours. Further plans were considered to develop it for even more apartments; however, as you can see in this photograph, that development has not happened.

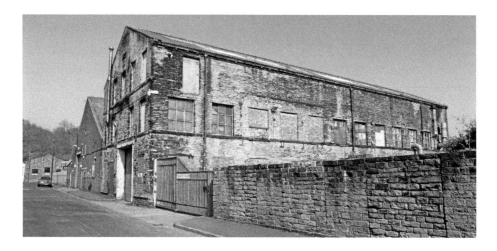

Grove Mills, Grove Street Brighouse. The name of the mill and the date '1864' is on the roadside front elevation. In 1860, forty lots of land were advertised and offered for sale. Grove Mills appears to be one of the first to be built on the land. As this was a greenfield site, Mill Street became the first street under consideration and shown on the sale plan; however, when Grove Mill was built the new street was named after the mill. Grove Street is still the name today.

Some of the early occupants in part of the mill include James Wood & Brothers, wire manufacturers. Their partnership was terminated in 1879 due to family bereavements. Another of the businesses was Booth Brothers (William and Lister), who were cotton doublers and warp makers, but in 1892 they, too, terminated their partnership. Lister continued the business at Grove Mills, while William started his own cotton doubling and warp-making business in a shed attached to Mill Royd Mill. Lister Booth died in 1913. Then, in 1939, the company reregistered as Lister Booth (1939) Ltd. In 1966 the decision was taken that the company would go into voluntary liquidation and was closed down.

Today, what is seen in the above image is all that remains of Grove Mills, which is now used by a number of small businesses; the remainder is a car park. The image below shows just some of the many employees who worked at Grove Mills.

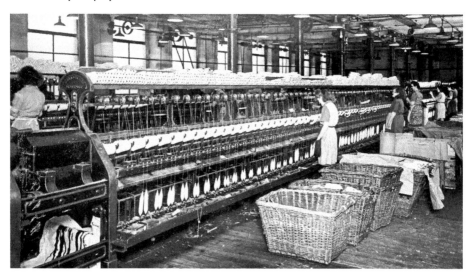

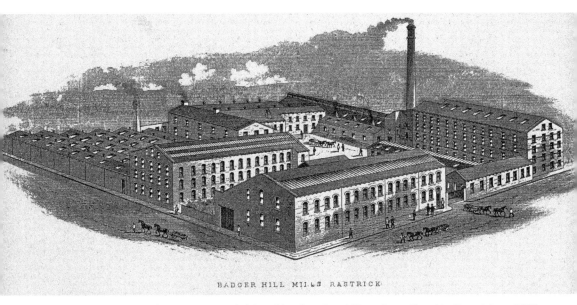

BADGER HILL MILLS RASTRICK

Badger Hill Mill at the junction with New Hey Road and Dewsbury Road in Rastrick, *c.* 1895. The whole site was redeveloped as a housing estate in the 1970s.

William Smith was born at Howcroft Head, Greetland, in 1839, where he attended the local dame school. This kind of school disappeared after the 1870 Education Act. He then went on to the Greetland Wesleyan Day School, but left before he was twelve so he could wind bobbins at the family warehouse, later progressing onto warp making.

After a couple of years his father decided that he was not able to make a go in the dyeing business and opened a new business at Scarbottom, Greetland, as a woollen manufacturer; however, this business failed. While his father John struggled on, he then decided that young William should learn a new trade and sent him to work at Benjamin Taylor's Barkisland Mills at Stainland. There he was taught woollen carding, scribbling and spinning. After eighteen months he left to work once again with his father at some rented premises at the Old Kiln End Mills in Elland. He began here as the foreman and after a short while was effectively running the business for his father.

With business beginning to take off, he and his father moved to some larger premises at Badger Hill Mills, Rastrick, where they established the company of John Smith & Sons, woollen manufacturers. It was an opportune moment in time and, with the change in styles, they took to making upmarket tweeds and stayed one large step in front of their competitors. Following the death of his father, his sons – William, Albert and Edward – and J. I. Mortimer took over the running of the Badger Hill Mills, with the company renamed as John Smith, Sons & Mortimer.

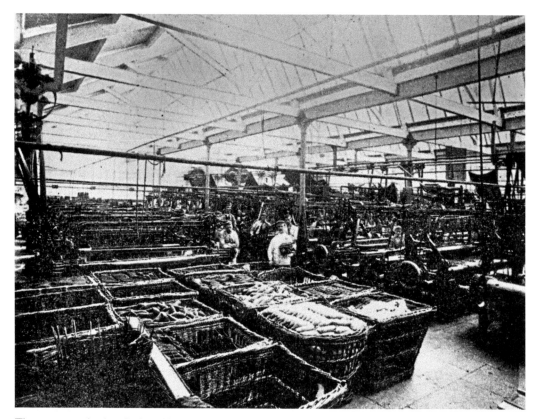

The weaving shed at Badger Hill Mill, c. 1895.

During the First World War the company was so busy that they extended the space they had rented in Rastrick Mills, until it eventually took over the entire mill premises. Rapidly expanding, the family took on more land from the Clarke-Thornhill estate.

At its peak the company operated three mills, a dyehouse, a drying shed, and storage for 3,000 bales of wool at any one time. When running at full capacity, they were able to scour 800,000 and dry 500,000 pounds per year. Product from the company was delivered to both a home market and overseas – particularly America. Power was operated from a 250-horsepower tandem-compound engine built by Wood Brothers at Sowerby Bridge in 1890. It was nicknamed 'Queen Mary'.

William died in 1922, by which time the company had become the largest woollen manufacturer for miles around.

Badger Hill Mills also had a number of fires at the premises, the last one being in 1970. There were then further problems; for example, the demolition of a chimney that had been deemed unsafe. The demolition workers had planned for the chimney to fall into an empty dam, but their plans went drastically wrong when the chimney twisted as it was coming down and fell on a previously undamaged part of the mill. The damage was not covered by the company's insurance. The remaining working part of the mills were closed and transferred to Gosport Mill at Outlane. In 1974, both the Badger Hill Mill and Gosport Mills went into liquidation. They were both subsequently redeveloped for housing.

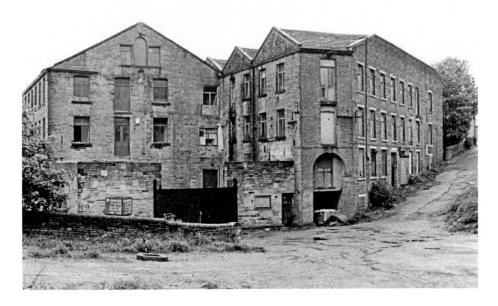

Spout Mills at Rastrick was a scribbling and spinning mill, built in 1850 by William Helm and his two sons John and Thomas. It was one of the oldest manufacturing businesses in the Brighouse area. In 1870 the business was registered as Thomas Helm & Sons (Joseph and George) – upmarket tweed manufacturers. The mills consisted of two large four-storey blocks and numerous outbuildings. The company employed 200 local people, who operated over 5,000 spindles and eighty power looms, all driven by a 200-horsepower steam engine. The mill closed during the 1960s and it was then used in multi-occupation by small businesses. In 2001, there was a large fire that practically destroyed a large part of the mill. Within five years the whole site had been demolished, clearing the way for it to be redeveloped for housing. Below is Spout Hill, which leads to Sage Grove, a small section of the new development.

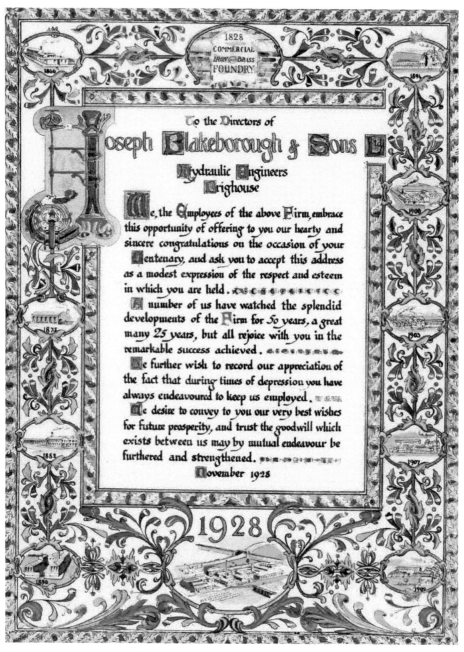

The employees at Joseph Blakeborough's company celebrated its centenary in 1928 by presenting the directors with this illuminating address. When the company was closed in 1989 the original framed address was saved from being lost forever. It is now in safe local custody and looked on with pride. Smaller copies were produced in 1953 and given to employees. My copy was found recently at a car boot sale, which allows me to share it with you.

THE AGE OF GLOBAL MACHINERY

Looking back at the engineering, iron, and brass foundry businesses, these have all taken a prominent place in the industrial life of Brighouse. However, as the industry of the town has changed, many of these trades have now almost disappeared into the history books. Though far from the scale they used to be, there are still a few remaining. In fact so many businesses have either downsized or closed it now appears there is a genuine shortage of this kind of skilled worker, not just in Brighouse but nationally as well.

Some of these businesses that have now faded into the mists of time have left an indelible mark on the town, ensuring their place in the history of Brighouse. One of these is Marsden & Stansfield Engineers, who, at their Central Brass and Iron Works, manufactured high-pressure boiler mountings. Like many of our local firms, they were heavily involved in war work during the First World War.

Charles Heward Broughton and his brother opened their business in 1864 at the Kirklees Ironworks at Mill Lane. There was a name plate on its Wakefield Road entrance: 'Charles H. Broughton – 1864 – Kirklees Iron Works'. Kirklees Ironworks was much larger than most of the others. They were not only engineers, but millwrights, machine moulders and all round general contractors. Sadly, this entire site was cleared in April 2017 for a new supermarket.

Then there was Denham & Pearson, who were ironfounders on Armytage Road. This company specialised in castings for woodworking machinery. Cockin Brothers had their steam and hydraulic works at Perseverance Mills (now the Prego Restaurant and Waterfront Lodge Hotel). Not only did this company do business locally, but they exported as well.

With Thornton & Sons (manufacture of wire-drawing machines) and William Bradley (machine makers, ironfounders and steam-engine makers), the town's engineering output was thriving and helping to keep Brighouse on the industrial map.

Another business that made a lasting mark on the town was Woodhouse & Mitchell. This company dated back to 1867 when Joseph Wood, John Baldwin, Samuel Mitchell and Richard Woodhouse – four young men who were working mechanics from Sowerby Bridge – started the company in Birds Royd Lane Brighouse, initially called Wood Baldwin Company. In 1873, the business moved to Clifton Bridge Iron Works. Following the death of Joseph Wood in 1881 and the retirement of John Baldwin, the company was renamed as Woodhouse & Mitchell. In 1963 it was acquired by Thomas Ward, a Sheffield-based company, and then in 1982 Ward's was taken over by the international conglomerate RTZ. Sadly nothing of the former Woodhouse & Mitchell business exists today, except for the memories of those Brighouse engineers that worked there.

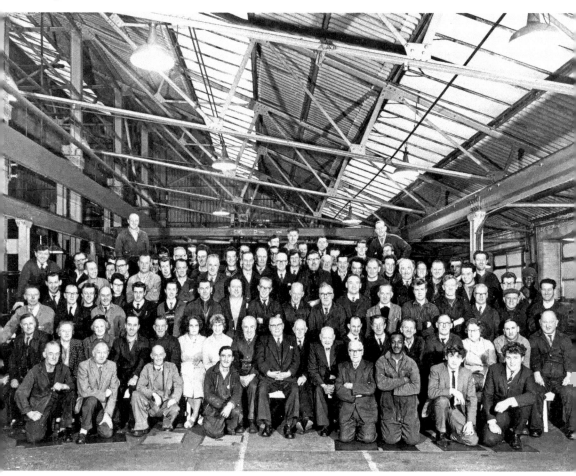

The Woodhouse & Mitchell Company started in 1867 as engine builders and general ironfounders. In 1872, as a well-established company, it was decided they had outgrown its existing premises at Birds Royd. New premises were found at Clifton Bridge and, when they had moved in, they were appropriately named Clifton Bridge Iron Works.

This photograph was taken *c*. 1963 – just a few years before the company closed.

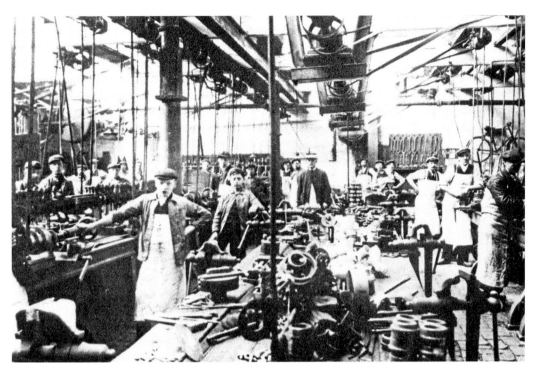

The brass shop. Small brass valves and fire equipment, including hydrants, were machined in this department.

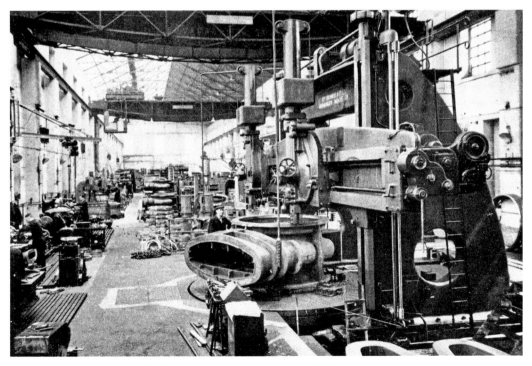

The large value machining and construction shop, *c.* 1965.

It was during the mid-nineteenth century that Robert Blakeborough tinkered about with valves at the family home, premises that are now occupied by the Direct2Mum children's wear and accessories shop on Bradford Road. From those small beginnings, and encouraged by his father Joseph, he moved to some small premises in Mill Lane. From this small home-based beginning, his company eventually grew to become a very large and internationally recognised business.

Blakeborough's was ranked among one of the foremost engineering businesses in the country. The company specialised in machinery and appliances for hydraulic purposes, with its core business being the design and manufacture of industrial water valves. Most of this work was specialised, bespoke manufacturing for the control of liquid flow for waterworks, docks and shipping, and, in later years, boilers. The company produced small, large and very large valves and had customers across the world.

In 1866, Joseph Blakeborough (the father of Robert) purchased the Commercial Iron & Brass Foundry (a company that had originally been established in 1828) in the Park Street area of Brighouse to form J. Blakeborough & Sons Ltd. Although the foundry has long-since gone, this street is still in the heart of the town centre.

The company patented its first fire hydrant in 1875. It purchased the Woodhouse Works site in 1890, which meant moving from the Park Street iron and brass foundry premises. The business was incorporated as a private company in 1916 and became a publicly listed company in 1928. The company was eventually to become one of the largest employers in Brighouse.

In 1926, the company manufactured what was the largest regulating valve ever made at the time by any engineering company in the world. It was delivered to its customer in Durban, South Africa, for the new Shongweni Waterworks.

The year 1965 saw the company taken over by Hopkinson's Holdings of Huddersfield. In 1986 a devastating fire in the company's century-old pattern shop was to be a major blow to the company. This was to create even further doubts and uncertainty about the company's future. The following year the company formed a partnership with Wolstenholme Valves (a subsidiary of Hopkinson's).

Blakeborough's closed down on 12 April 1989, which brought an end to one of the town's most successful businesses. After the gradual decline and ultimate demise of this large company, there has been a number of new valve-manufacturing businesses in Brighouse, including Blackhall Engineering, which was formed in 1965; Kent Introl in 1967; Alco Valves in 1977 and GA (Golden Anderson) Valves in 1985. Today these businesses are carrying on the tradition of supplying products to both the home and overseas markets, and maintaining Brighouse's long-held standard of quality product and service.

The site was bought and redeveloped by Fine Art Developments plc, a Bradford-based company that started in 1962. This company's core principles were the design and manufacture of greeting cards and gift wrap, together with a mail-order service for national charities and fundraising.

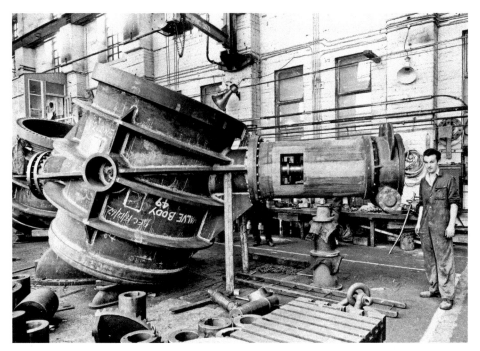

Joseph Blakeborough & Sons Ltd. This is a fabricated steel butterfly valve that has been manufactured and is now ready to be sent to the customer – the Dungeness nuclear power station in Kent. Apprentice Christopher Parker can be seen looking on in 1963.

Just a small part of the 350,000 square foot Hallmark plc distribution warehouse, which was built on Blakeborough's former Woodhouse site. The complete warehouse racking system will hold 58,000 full pallets. The warehouse is large enough to house five full-sized football pitches, along with their spectator stands. It has approximately 1.25 miles of perimeter security fencing.

The company started redeveloping work in 1990 on the former Blakeborough site. This involved the construction of what was, at the time, said to be one of the largest warehouse buildings in Europe. I recall visiting the site as the local crime-prevention officer based at Brighouse police station and being told that this warehouse was big enough to house five full-sized football pitches, along with the stands. The site was protected by over 1.25 miles of palisade fencing. At its peak, the number of employees working for Blakeborough's was around 2,000. Even to this day the warehouse has only employed between 75 and 180 people. The current site is approximately 350,000 square feet in total. Once the warehouse was completed it enabled the company to bring together its then three sites together under one roof.

In 1997 Fine Art Developments demerged into two separate companies: Findel, which dealt with all the mail order side of the business, and Creative Publishing, which dealt with all the company's publishing and manufacturing side.

In September 1998, the privately owned American-based company Hallmark (based in Kansas City and still owned by members of the founding Hall family) bought Creative Publishing plc and was later rebranded as part of the Hallmark Corporation.

Two other buildings on the Blakeborough site were also initially redeveloped by Fine Art Development Co. and later occupied by Hunt & Broadhurst. This was a company originally based in Oxford that sold stationary under the 'Oxford' brand name; it later moved to Brighouse. Since 1982 this company no longer exists, but the Oxford brand is now owned by the French company Hamelin. The former Blakeborough office building was initially used by Fine Art, but in later years became surplus to requirements and was eventually demolished.

I remember visiting the Blakeborough offices during the 1980s while serving as a police officer after the Blakeborough pattern shop and other properties near the office building were seriously affected by large fires. Along with other officers, I was employed as a firewatcher, keeping a lookout for those who may be starting the fires and for any properties that had been set alight.

Part of the Hallmark distribution warehouse has a dedicated area for gift wrap paper conversion. Once an individual roll – measuring 13,500 meters – has been placed on the machine, it will produce sixty-three individual shop-ready 4-meter-long rolls of gift wrap paper per minute. Here are just a few of the 180 staff that work in this huge warehouse. The company produces 16 million individual shop-ready rolls annually from 46 million meters of wrapping paper, which is produced and shipped over from USA.

THE TOFFEE INDUSTRY

The family name of Turner conjures up all kinds of memories, not just for the people of Brighouse but for many people beyond its boundaries as well. Let us go back almost 130 years, when John Henry Turner and his wife Mary Ann Stone were making toffee during the late 1880s in their home. In those early days Mary was making what became a real delicacy; she shared it with her family, friends and neighbours. So popular was her delicious home-made treats that John Henry started a small business selling it locally. Working together, the business slowly began to make a profit.

Their home-made toffee became so popular that it made them enough extra money to make John Henry consider leaving his regular job at the Halifax Co-op and go into full-time production. Then, in 1896, he met George Wainwright (another employee of the Co-op) and between them they decided to leave the job security of the Co-op and take up toffee-making together on a full-time basis. From small beginnings, the business grew rapidly. So much so that very soon after they had to buy even larger premises in River Street, Birds Royd. The business was still growing and expanding at an almost unstoppable rate, and it was not long before they had to consider moving again to even bigger premises.

In 1908 they moved from River Street into the empty five-storey Camm's cotton mill at Brookfoot (a property that is now occupied by Avocet Hardware (UK) Ltd). They were embarking on an expansion programme that was literally a do-or-die situation. The company was to become the household name of Turnwright's, the Turner & Wainwright Toffee Co., and became a brand name that was synonymous with quality.

Throughout the First World War every 'comfort parcel' that was sent from Brighouse to France contained a slab of Turnwright's toffee – a welcome gift and a luxury to the lads at the front.

Sadly, through the late 1920s and early 1930s the company hit a slump; with many major customers taking their accounts elsewhere, the business was on the verge of collapse. However, for a short period of time, John Henry Turner's son George stepped in, creating the name of Turner & Wainwright (1933) Ltd, but sadly it wasn't enough. The building was sold not long afterwards to a mill owner from Rastrick. George Turner, however, had his own business interests at Owler Ings Mill, which many readers will recall burnt down during the 1970s.

For most of this century the Turner family employed thousands of Brighouse people. Quite often whole families would have worked at either the toffee works or the mill in Owler Ings. The Turner family will always be part of the history of Brighouse.

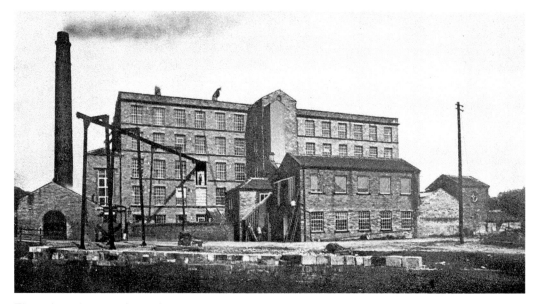

There have been at least three mills in this area of Brookfoot dating back to the 1600s, the first of which was a corn mill. The mill seen here was built *c*. 1865 and at the time was owned by Samuel Leppington and operated by William, Alfred and Nicholas Cunliffe Camm, trading as Camm Brothers Spinners & Cotton Doublers. By 1882 the mill had over 400 employees. On 31 July 1883 the partnership was dissolved when William and Nicholas retired. This photograph is dated *c*. 1909.

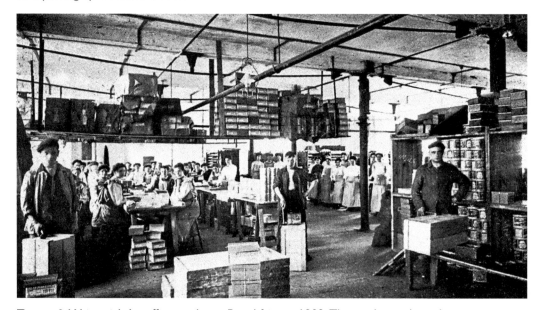

Turner & Wainwright's toffee works at Brookfoot *c*. 1909. This is the packing department, where the majority of employees are women who would pack the individual boxes. The few men working in this department would pack the boxes into packing cases and make them ready for delivery to customers.

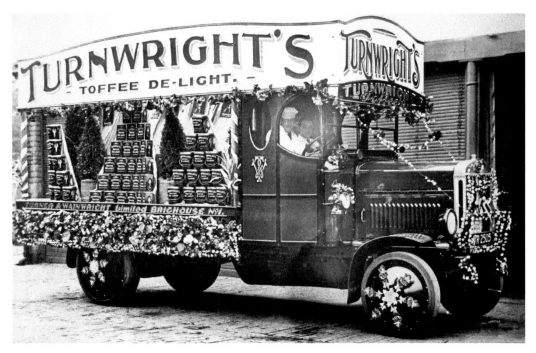

Turnwright's, the trade name for Turner & Wainwright's, can be seen here on one the company's delivery vehicles. It is decorated and ready to take part in one of Brighouse's community demonstration parades. This was the same kind of event as the modern-day Brighouse Charity Gala. In those days, the concept of a float taking part was to promote what local businesses had for sale, rather than children representing a local organisation. It still raised money for local hospitals and other worthy causes.

With the demise of George Turner's efforts to resurrect the family firm at Brookfoot, the building was soon to have a new lease of life. Following the bombing of the Meredith & Drew factory and destruction during the London Blitz in 1940, the company relocated its production to Oldham, High Wycombe and Brighouse. The company headquarters was moved to Ashby-De-La- Zouch in 1943. Meredith & Drew advertised itself as 'Britain's biggest biscuit bakers' in 1946 and by 1951 employed 2,500 people. In 1954 the company closed its Brighouse factory and reduced its seven nationwide factories to three at Halifax, Cinderford and Ashby-de-la-Zouch.

Following the closing of the Meredith & Drew factory at Brookfoot, the mill remained empty until November 1955. The mill was chosen as the site for the new Kosset Carpet Co., a business that was founded in the same year by five companies under the banner of Tufted Carpets Ltd, whose products would be sold under the trade name of Kosset Carpets. The five companies were Carpet Manufacturing Co., John Crossley-Carpet Trade Holdings, Brinton's, James Templeton and Thomas Bond Worth.

Once the decision had been taken, extensive work had to be carried out in the mill. All the work was completed just in time for the official opening of the new factory on 27 September 1956. It transpired that the visitors got more than just a simple opening ceremony. They were given the opportunity of looking around the factory with its full-scale operations in progress throughout the entire mill premises.

Mass advertising in national newspapers and magazines, along with the use of new techniques to analyse readers by income, age, sex and region, saw an even bigger publicity drive that enabled them to maximise their sales. The company's secret weapon, however, turned out to be even more successful: Susie the white fury cat. She was filmed and photographed laying on a piece of Kosset red carpet, showing warmth, comfort and, of course, suggesting an air of luxury with it, which won over a legion of new customers.

In 1965, Thomas Bond Worth ended its association with Kosset and in 1968 John Crossley-Carpet Trades Holdings Ltd of Halifax and the Kidderminster-based Carpet Manufacturing Co. bought out the interests of their other two partners. Carpets International was formed in 1969, which then consolidated their interest in Kosset.

In 1985, Kosset was acquired by the John Crowther Group, which, in turn, was acquired by Coloroll in 1988. Following the collapse of Coloroll, the company was taken over through a management buyout at a cost of £17 million. In 1992, Kosset was sold to Shaw Industries of Georgia, USA. Kosset Carpet is still available through the retail chain Carpetright.

Following the turmoil of the 1980s and early '90s Brookfoot Mill became the new home of WMS PVCU Hardware Ltd. This company was later known Avocet WMS Hardware Ltd but was dissolved in November 2012. Shortly afterwards the business was rescued by the Jain family from the administrators. This family have business interests not only in the UK but also in Malaysia, India and China.

Since those dark days the company has been successfully turned around. The Jain family's ownership has brought with it many benefits, not least a highly experienced management team that has frequently demonstrated an ability to turn around the fortunes and reputations of companies.

Brookfoot Mill has had a number of ups and downs during in its lifetime – from a nineteenth-century cotton industry through to the twenty-first century as a supplier of window and door hardware. Let us hope that it has turned the corner and the legacy of Brookfoot Mill being a major employer will continue.

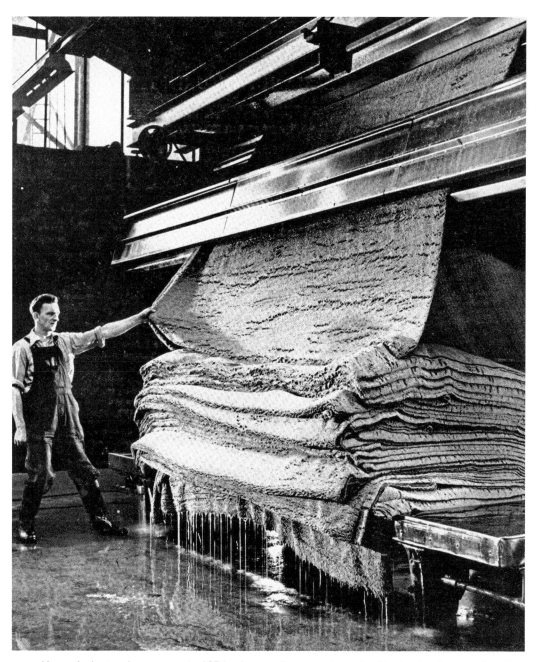

Kosset's dyeing department in 1956, where rolls were piece-dyed in dye kettles – at that time they were the largest in Europe. In each dye cycle approximately 500 square yards of carpet was dyed. When the cycle was complete, the liquor is cooled and the wet carpet was carried from the dye vessels onto large stainless steel trolleys. Once loaded, this trolley, complete with wet carpet, would weigh in the region of 5 tons.

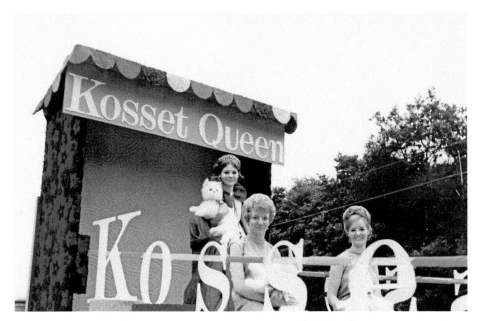

The Kosset Carpet Queen and her two attendants in 1968. The float is conveying them to Wellholme Park as part of the Brighouse Charity Gala procession.

Here are just some of the seventy-plus people who now work at Avocet Hardware (UK) Ltd. They are in the same premises that toffee was produced and sent to the Western Front between 1914 and 1918, and where Kosset produced carpet for the nation. The director, Dr Sachin Saigal (second from the left), at Avocet Hardware said: 'We are a leading company in distributing quality door and window hardware and innovative patented security products with an assurance to deliver unparallel customer service. We are a growing company with all the industry accreditations.'

BRIGHOUSE GOES HIGH-TECH

When Noel Fitton (b. 16 December 1911) left Hipperholme Grammar School in 1927, on his sixteenth birthday, he shook hands with his headmaster and was told: 'Well Fitton you'll never be out of a job, we'll always need road sweepers'. As he walked out of the school gates for the last time and made his way down Denholmegate Road to Hipperholme to catch the tramcar back to Brighouse, he was understandably downhearted at the headmaster's comment. Within just a few years he had set up his own business, going on to build the Ambassador Radio & Television and Stereosound Production companies.

Advertisement for an Ambassador television.

Noel Fitton.

His working life began in the office at a local motor business where his father was in partnership. It was not long, however, before Noel left and started to dabble with wires in the attic at home. It was there that he put his first radio together, then went on to sell it.

Not long after he rented some premises in Bramston Street and engaged his first employee. In those early days you could get a wireless for 2 bob down and 2 bob a week (the British 2s coin was also known as 2 bob – equivalent to 10p today). Backed by a hire-purchase company, his business began to grow, but he did not think that with the undertaking he had to buy back any bad debts. The bad debts were mounting up in excess of new business. Some sets came back, others did not, and then the hirer vanished.

A way out of the situation had to be found, otherwise the business would fail and he would indeed have to take up road sweeping if that happened. He decided to sell directly to the public and avoid hire-purchase debts. This became the turning point; soon he had opened fourteen retail shops selling his own product. The first shop was in Halifax and it was the outstanding success of this shop that made him decide to expand. Others followed in Bradford, Leeds and other Yorkshire towns, along with Manchester and Salford. Working hours were long, as shops stayed open until late at night in those far off days. His Halifax shop was still often open after 11 p.m. on Saturdays.

At that time a radiogram in a walnut cabinet sold for less than £15. The name he gave to this product was Ambassador, and more Ambassador radiograms were sold in Halifax than any other make at that time. Advertised brands typically sold at around £25, so the Ambassador was certainly good value for money as you saved £10.

By now Noel was really in business, and moved from Bramston Street in Rastrick to Hutchinson Lane, just off Commercial Street, in the heart of the town centre. It was there he started to make cabinets as well as the electrical chassis. This meant he was now the first manufacturer in England to produce both the radio and the cabinet. The big established names of the day could not understand how it could be done – 'How could a radio manufacturer make cabinets?' Despite Noel's status at school, he always enjoyed woodwork lessons; perhaps this was his foundation to taking on the challenge of cabinet-making.

Then came the war, which resulted in the shops being closed. The one in Leeds was the last to close, and that was when there was nothing more to sell. Noel once commented that when all the production of radios had stopped, his £15 radiograms were selling for £120 second hand.

The Ambassador factory turned to government work, which included canteens, factories, military camps, hospitals, airfields and production of amplifiers for 'Music While You Work'.

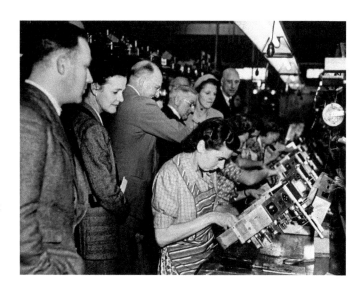

Ladies at work in the Princess Works, Birds Royd, in 1951. The people overlooking the ladies' shoulders are dealers who would come and visit the works and be shown the work that went into the production of the Ambassador television.

Noel took on jobs for the government that no one else wanted, which turned out to be the difficult, non-profitable jobs. Nevertheless, some of the things he made were used in some of the most important actions of the war.

After the war, Ambassador moved into exports. An entirely new model designed for export featured what Noel called 'extended scale'. This was a form of band-spreading that facilitated tuning shortwave stations; when it was announced, the radio industry was in uproar. Everyone else had brought out what remained of their last pre-war designs and here was this little firm in Yorkshire with something brand new and aimed directly at the export market. Production for the home market was strictly controlled so a potential overseas market was wide open for Ambassador.

With the early end of the Far East War, the radio industry and the BBC turned towards the return of television, which had been abruptly ended in 1939. Ambassador was not geographically well placed to experiment with television, with Brighouse being way beyond the reception area of Alexandra Palace.

However, in 1949 this problem was overcome by the Ambassador engineers building a signal generator that could imitate a pattern to that of a television transmitter. Work began designing a 12-inch screen model. Noel – always on the alert for a new idea – had been invited to spend an evening watching television by a friend in the London area. At the end of the programme he announced that his television models would be designed to fit into the corner of a room. The first-ever Ambassador television took a triangular shape to fit in a corner, as did all other Ambassador models.

As the business expanded he went to look at some larger premises in Princess Street, Birds Royd, with his bank manager. The premises were in a serious state of neglect, but, following a discussion, the bank manager agreed to a loan of £8,500. The business continued to prosper using the idea of manufacturing a television as a piece of furniture. Every transformer and coil was manufactured at the Princess Works.

Once a television service was, more or less, countrywide in the UK, it was no longer a growth industry and became instead more dependent on the replacement market. Some manufacturers had already gone out of business, and Noel realised that his company's survival may depend on being linked with someone else. This resulted him taking steps to sell the company to what remained of the original Baird television business.

When the Ambassador trademark had lapsed he applied for its reregistration, his intention being to start a new business in 1958. This time it was not television or radio, but stereo. The Ambassador name was not available for this venture, so the name of choice was Stereosound. Their focus was not just electronics, but cabinet-making as well. This business went on to employ 285 people, mostly local people from Brighouse. With a little over 30 per cent of the output being exported and a turnover of £4 million, the company also took on premises in Elland. This was where one factory produced cabinets and a second produced 1,000 audio units a week.

Noel Fitton once said, 'If you leave school today as I did at the bottom of the class, look for a job in which you can find real interest and stimulation – look for a job that really suits. If you've made the right choice and the enthusiasm is there then the money should take care of itself' – sound advice, even today. Noel Fitton, considered by many as a man ahead of his time, passed away on 2 August 1998.

This Stereosound advertisement dates back to January 1967.

FROM AEROPLANES TO PALACES – WE CARPETED THEM ALL

At the beginning of the seventeenth century, carpets as floor coverings were almost unknown in the United Kingdom. As a concession to royal standards of hygiene the hay from the floor of Queen Elizabeth I's Presence Chamber was changed once a month in Greenwich Palace. It is written that Cardinal Wolsey went even further at Hampton Court by changing the hay daily.

The earliest floor coverings would have been rush mats and probably skins of animals. It is known that Eastern carpets were first brought to the country by the crusaders during the twelfth century. With the establishment of the woollen and weaving industry during the reign of James II, woven and pile fabric became fashionable in the homes of the well-to-do.

By 1822, when Firth's was founded in Heckmondwike, the carpet industry as we know it today was born.

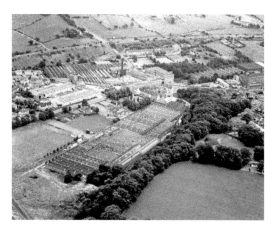

T. F. Firth's Carpet Co., Bailiff Bridge, c. 1980. The top half of the photograph, with the mill buildings around the chimney, was where the company started. The Victoria Road sheds are in the foreground, which is where the tufted carpet was manufactured. When the company closed in 2000 the two sites were bought for housing development and the company that had started in Bailiff Bridge in 1867 was demolished.

In 1867 Thomas Freeman Firth, the senior partner, founded the firm of Firth Willans & Co. – carpet manufacturers at Clifton Mills, Bailiff Bridge, Brighouse. In 1875, Mr Willans left the company and it was renamed T. F. Firth Carpet Manufacturing Company. The company became so successful that in 1888 it established one of the earliest carpet-manufacturing businesses in the USA, based at Firthcliffe in New York County; later a carpet plant was also established in Auburn. In 1944, however, all the company's American interests were sold to American nationals.

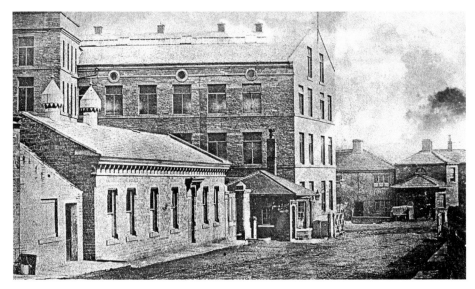

In 1867, Thomas Freeman Firth and John Willans bought this old worsted mill at public auction in Halifax. This was to be the home of what became known as T. F. Firth Carpet Manufacturing Co. at Clifton Mills in Bailiff Bridge until it closed in 2000. It was later demolished in 2002. Note the single-storey building next to the mill. That was the toll house and toll gate, which was situated on the Odsal–Huddersfield turnpike road.

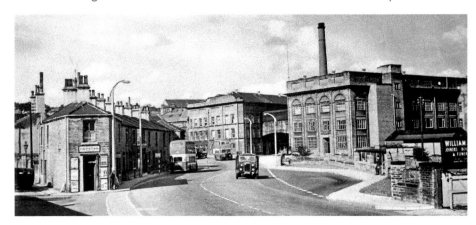

Bailiff Bridge during the 1960s. The village skyline was dominated by the two large mill buildings that were either side of Birkby Lane. The two buildings were connected by two tunnel walkways; one of these can be seen between the two mill buildings. They were taken down after the company was closed. All that remains today is the mill building on the right, which was built in 1909 and served as the company offices.

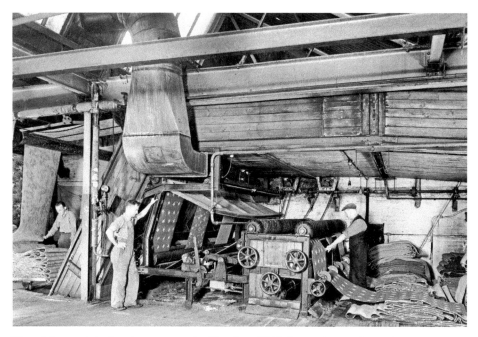

The sizing and drying department in October 1949. It was here where the new carpet was put through a process that stiffened its backing.

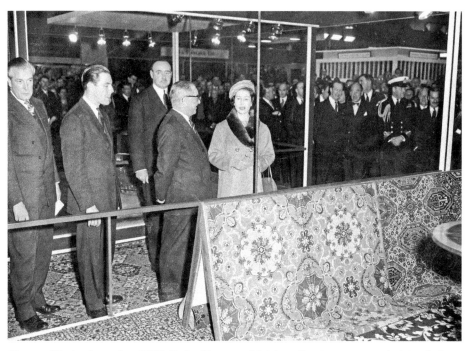

Queen Elizabeth at the 1959 Earls Court exhibition. She is accompanied by (left to right): The Queen's equerry, Michael Akroyd (Firth's Carpets), another of the Queen's equerries and Leonard Cordingley (Firth's Carpet sales director from 1945). They are standing in front of Adam's-style Wilton carpet.

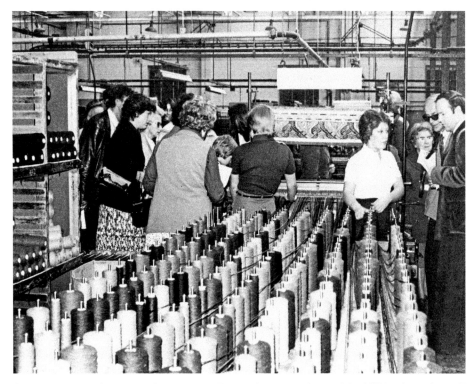

Spool Axminster's setting department during the open day in July 1976 when the mill was open to the public, particularly the families of employees. This particular role was a highly skilled part of the manufacturing of Axminster carpets.

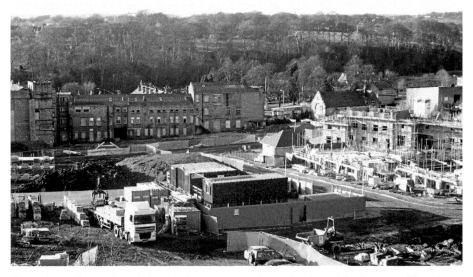

Once the mill was closed the whole site was to be redeveloped for housing. Here large parts of the mill complex have already been demolished and the housebuilding is well underway.

THOMAS SUGDEN'S FLOUR MILLS

As far back as the twelfth century, the Brighouse district had a small number of corn mills. The milling trade was a monopoly as all corn had to be ground in the mills and anyone who failed to do this was fined. In 1297, Eva del Broke was accused of operating some hand mills that were described as causing damage to the lord of the manor.

Thomas Sugden was by far the most well-known name in the annals of Brighouse as a miller. He was born in 1796 in Bradford. He served an apprenticeship as a grocer in Bradford. It was probably through this work that he came into regular contact with flour. It could well have been through this contact that he saw it was such a poor quality – possibly that he could do

 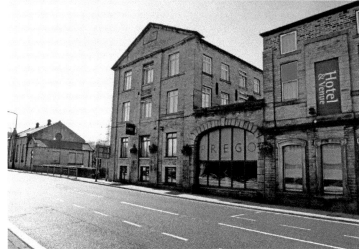

Left: Thomas Sugden, 1796–1876.

Right: In 1829, then aged thirty-three, Thomas started his career as a miller after his purchase of Thomas Richard Sutcliffe's corn-milling business. In 1831, in partnership with two other men, he acquired the newly built four-storey Perseverance Mill. At the top of the front elevation the following inscription can still be seen today: 'Perseverance Mill Erected 1831'. These premises now form part of the successful Waterfront Hotel and Prego Restaurant.

better. Having served his time as an apprentice, in 1818 he moved from Bradford to Brighouse, where he started his own business as a grocer at the bottom of Parsonage Lane. His business soon began to flourish, so much so that he decided to move into larger premises at Bridge Corner, near the Anchor Bridge. His first move into making flour was with a Mr Widdop – could they make flour to the quality Sugden demanded?

In 1842 his sons – David Goldthorpe Sugden and, a few years later, Richard Sugden – joined the family business. Thomas retired in 1861, leaving it in the hands of his two sons. Sadly, in 1871 David died after a tragic accident when he fell down some stone steps outside his home, which left Richard as the head of the business. By the time of Thomas Sugden's death on 4 November 1876, the business had been registered as Thomas Sugden & Sons Ltd.

Thomas had seen his business grow to such an extent that he took over the whole of Perseverance Mill, but even that soon became too small for his rapidly expanding flour-milling business. He found and purchased new premises – Brighouse Mill – following the death of its owner, corn miller Thomas Richard Sutcliffe, who had built the old Brighouse mill in 1855. After expansion to four separate mills, it was now time for Sugden's to consolidate them all into one – Brighouse Mill.

The company was now operating just the old and enlarged Brighouse Mill, situated on a commanding site on the north side of the canal. It is described as a four-storey property, built of stone and as having two huge waterwheels. It also operated from the Upper Mill in Bridge Road (see page 25). In 1891 the Perseverance mills were closed.

On Wednesday 14 August 1895, a huge fire struck the Brighouse Mill. It was reported after the disaster that at 11.05 p.m., Harry Robinson, a stone-dresser employed at the mill, went outside for a smoke and stated that he could smell the distinct aroma of burning bread. While the rest of the town centre area were retiring to their beds for the night, it was panic at the mill. The steam buzzer echoed across the town centre. The Victoria Mills Fire Brigade, followed by the Borough Council Fire Brigade, were at the scene within minutes, discovering that the south-west corner bottom floors of the four-storey mill were blazing.

By 11.20 p.m. the fire was threatening to engulf the whole building. The fire brigades struggled to raise enough pressure to reach the roof. Hundreds of spectators gathered across the river in Cliffe Road, which overlooked the raging inferno. By 1 a.m. the fire was at its peak; the town had not seen anything like this for over twenty years.

Some commentators dared suggested Sugden's was finished, but they had not considered the tenacity and strength of character of Richard Sugden. Within thirteen months the mill was back in full production. The fire was attributed to overheating through friction of the coupling of the water gear. Miraculously, no one was hurt, nor were any of Sugden's delivery horses. The incident did, however, raise serious doubts about the capabilities of the Brighouse firefighting services.

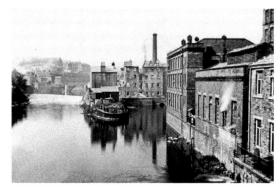

The extent of the damage the morning after the fire.

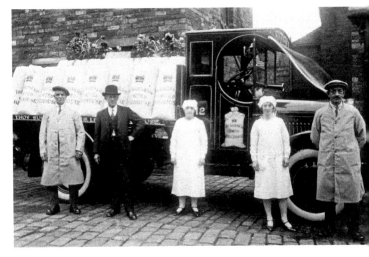

When the use of four-legged horsepower changed to that of motorised horsepower, Sugden's had a fleet of delivery vehicles. This one from the 1920s is fully loaded and ready to deliver its load of flour.

This was not the only disaster to hit the company. On Friday 20 September 1946, the worst floods for half a century swept down the Calder Valley, with Brighouse Mills in the path of a raging torrent; however the rebuilt stone edifice that Richard Sugden had built after the 1895 fire held firm.

The six-storey grain warehouse by the side of the canal caught fire on Wednesday 9 October 1963. This was market day in Brighouse and the town centre was packed with shoppers. Hundreds watched as six fire brigades fought to save the building and the 900 tons of grain it contained inside. With millions of gallons of water poured inside, the grain became swollen and, combined with the weight, the building could only stand so much. Massive cracks soon began to appear, which resulted in the building being written off. Two years before this disaster the main mill had another storey added in July 1963, which raised the height of the mill a further 20 feet.

The first approaches for the company to become part of Allied Mills – one of the world's largest millers, producing an estimated 19,000 tons of flour each week – were made in 1961. The negotiations were completed by February 1962 and Sugden's became part of Allied Mills. Richard Sugden, the grandson of the founder of the company, stayed on until November 1962. At this point he was sacked as the managing director of Thomas Sugden & Sons Ltd, but was promptly re-employed as the managing director for the whole of Allied Mills.

Expansion plans were announced by Allied Mills in 1995, but they were at the expense of a number of smaller mills being closed down, including Thomas Sugden's & Sons Ltd. In 1997, the gates into Sugden's were closed for the last time; employees left with heavy hearts, leaving a company many had worked at for all of their working lives. Once the gates were locked the site changed hands, and in 2001 plans were submitted to build a new swimming pool and retail outlets, but ultimately they did not come to fruition.

In 2011, joint owners Leigh Topping and Euan Noble took over the derelict Brighouse Mill. Within just three months they had created a business plan, secured planning, spent over of £1million, formed a team, transformed the derelict mill, and opened the doors. Today the ROKT Climbing Gym is considered as one of the UK's most innovative and inspiring climbing centres. With an ever-growing membership, new life has been given to one of the town's landmark buildings. I am sure if Thomas Sugden could return today and see what has happened to his mill, he would pleased to see that two young men have created something that the town can be proud of.

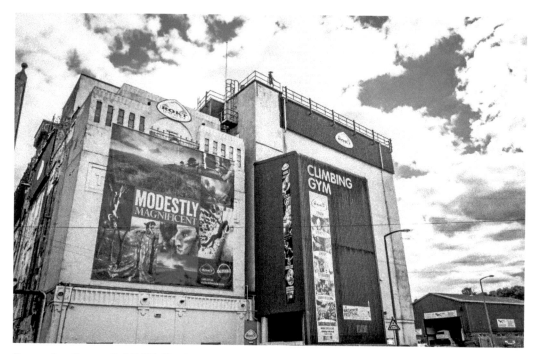

Formerly a flour mill, ROKT Climbing Centre in Brighouse is now home to more than 32,000 members and features 4 kilometres of bouldering, a 21-metre indoor lead wall, a 250-foot caving system, plus spin cycling, escape rooms and more.

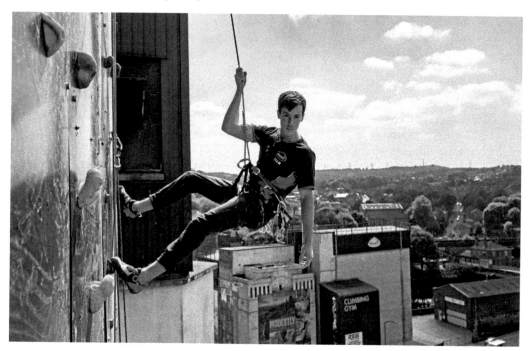

Team GB climber Luke Murphy climbs one of the highest routes on ROKTFACE – the UK's highest man-made climbing wall at ROKT Climbing Centre.

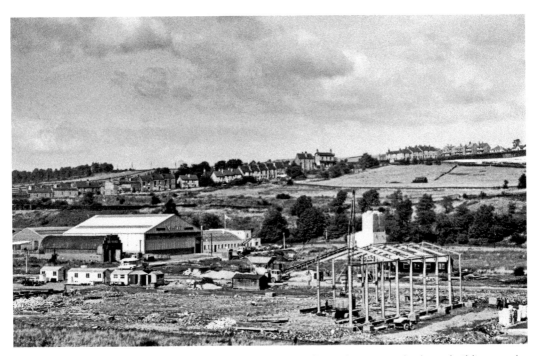

Construction work on the new Armytage Road industrial estate – the large building on the left is British MonoRail (Brighouse) Ltd, which opened in 1957. The small building to its left is Stove Enamellers, which moved to this site in 1957. This company, now known as Sherwood Coatings, is still on the estate.

When Sir Titus Salt, Baronet of Saltaire (owner of and resident at Crow Nest Mansion Lightcliffe (1867–76) first looked at the land between Alegar Street/Wakefield Road and where the present-day M62 motorway bridge is in Brighouse, he considered it a suitable location to build his model village and mill premises. The land was owned by Sir George Armytage of Kirklees Hall, who, when he was approached, decided not to sell it at that time. This decision resulted in Sir Titus Salt creating his village and mill premises at what he called Saltaire, in Bradford.

How did this land later become the Armytage Road industrial estate? In 1860, land was sold at auction, which included part of the industrial estate site we know today. The auction plans clearly show a number of proposed roads, which now form part of the present industrial estate area: Armytage Road, George Street, Arthur Street and William Street. One of the street names, 'Harriet Street', was not adopted; instead it was called Phoenix Street, the name given to Thomas Blackburn's new cotton mill built there. It is likely the original names were from the children of Sir George Armytage (1819–99) the 5th Baronet.

Nothing further happened until after the Second World War, when, in November 1945, the Brighouse town clerk reported to the council that he'd had a meeting with George Stead, a partner in the firm of Storey & Stead who were the agents for the Kirklees estate. The meeting was about the Wakefield Road land and the council possibly purchasing the 37-acre site for industrial redevelopment. A proposal to sell the land was sent to the council for £350 per acre – £12,950 in total. The council submitted an alternative offer of £9,000, which was refused. An alternative offer of selling the council 16 acres, 1 rood and 30 poles for £9,000 was sent in May 1946.

The council meeting resolved the matter by instructing the town clerk to take steps and obtain a compulsory order for all 37 acres. In June 1946 the Brighouse (Wakefield Road) compulsory purchase order was issued. At this time the land was used for agricultural purposes, and the site had little going for it other than five poultry runs and the remains of an old explosives hut.

On 2 September 1947, the council received a letter from the Ministry of Town and Country Planning that gave the minister's approval to acquire the 37 acres for an industrial estate. Further correspondence gave them consent to borrow £9,880 to purchase the site. Several months went by before a provisional layout was presented to the council. You cannot have an industrial estate without a good road network – this was something quickly identified. The new road and sewer construction costs amounted to £8,986 7d.

Blakeborough's had made an offer to lease up to 10 acres for sports facilities for their employees. Blakeborough's offer – accepted in principle – was to include a bowling green and tennis courts. The council wanted to attract new business to the proposed Wakefield Road industrial estate to show and encourage industrialists what was on offer. To encourage the business community the council held a presentation at the Brighouse gas showrooms on 30 March 1949.

Something had to be done with the land in respect of the existing tenants. This included Mr Pearson Marsden and his Shoesmith Farm, who, along with a Mr Martin, had been using the land on an annual tenancy agreement that was subject to a two-year notice to quit and had to commence on 2 February in any given year. Once those problems were ironed out things began to progress, with Brighouse Motors being one of the first businesses to take on a small area to store some of its vehicles.

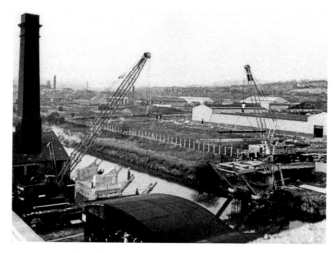

As the construction work of the new road bridge across the canal started in 1961 and became known as Blakeborough's Bridge, new buildings starting to appear on the Armytage industrial estate. The new bridge was a private vehicular/pedestrian bridge to link Blakeborough's works and offices in Birds Royd and River Street to Sherwood Works on the industrial estate. The bridge was closed to vehicles c. 1980. The bridge has remained closed because of health and safety concerns and due to the fact it was built to an American specification and not to British standards. After the demise of Blakeborough's the bridge was considered as a possible river crossing to bypass the town centre, but it was judged too costly in comparison to the numbers of people who would use it – estimated costs were in excess of £100,000.

Bailiff Bridge Dragons cycle speedway – A and B teams.

One of the first companies to move onto the estate was local haulage company Roberts & Smith (Brighouse) Ltd, who moved from its depot in Mill Royd Street. This company was in existence until 1975, when it was voluntarily wound up. July 1951 saw the directors of Reliance Garage (Brighouse) Ltd take up a lease on a new site.

Another of the early and more unusual offers accepted by the council was for a cycle track, which had been requested by George Holdsworth of Bailiff Bridge. He had to pay £1 per year and take out the necessary insurance. For a team that raced in Bailiff Bridge why would it relocate to the Armytage Road industrial estate? Their original track was on the site of the old tip in Bradford Road (between Bailiff Bridge and the old railway bridge on the way to Wyke), but, as with old tips, the surface was often littered with broken glass bottles and tin cans that would find their way to the surface. This popular activity lasted for two to three years until national service called many of the lads up at the age of eighteen.

Another of the very early companies to take a lease on part of the Armytage Road industrial estate was British MonoRail (Brighouse) Ltd, which opened in a large new building and office block in 1957. The company manufactured automatic transfer and overhead handling equipment under licence from the American MonoRail Company of Cleveland, USA. The company was closed in 1986 with the loss of eighty jobs.

In 1952, George Illingworth and Stanley Scaife went into business together as stove enamellers in Bradford. By 1957 the business was growing and doing well, so much so that they looked for new and larger premises. An opportunity presented itself when Brighouse Borough Council were actively looking for tenants for their new Armytage industrial estate. The partners made the decision they would move the business to this new site at Brighouse once they'd signed the lease, which included an acceptance of the £58 10s annual rent charge. Money was tight in those days and having new premises built was out of the question. Although it was then ten years since the end of the Second World War there was still a national shortage of steel for construction. Their answer was to buy a second-hand building and rebuild it on their new site. In 1958 the company was solely owned by the Illingworth family, with David joining his father in the family business.

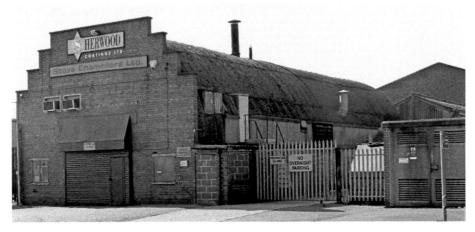

Having moved on to the industrial estate under the name of Stove Enamellers in 1957, in the early 1970s the family changed the name to Powder Coatings Ltd. It was later changed to its present name of Sherwood Coatings Ltd. The business is now run by the grandsons of the original founder and is still in the second-hand building. The company has now been on the industrial estate for sixty years and is probably the oldest business to have started on here.

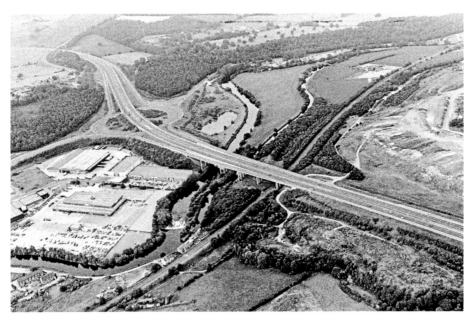

The M62 Clifton–Brighouse viaduct with British Car Auctions (BCA) in the foreground. This was opened in 1972 and was described as the most modern auction centre in the world. It was located on a 15-acre site with facilities to handle over 1,000 vehicles. At that time it had two auction rings, a restaurant, snack bars, automatic car washers and a helicopter pad, with parking for 600 customer vehicles. A Tate and Lyle distribution centre was originally behind the BCA site, which stands next to the roundabout and was also opened during the 1970s. This property has since been occupied by a number of companies. It is now part of Clipper plc, the international logistics company.

EPILOGUE

When it was suggested that I write and illustrate an industrial history of Brighouse and its surrounding communities, the initial reaction from some was: 'Did Brighouse have any industry?' I knew – and have always known – that Brighouse has been a powerhouse of industry over its long history. While it was not on the scale of its near neighbours of Halifax, Huddersfield, Bradford or Leeds, but for its size the town has been at the forefront of industrial diversity.

Industrially, one of the main advantages of Brighouse has been – and still is – its geographical position: there is always room for industrial expansion and for businesses to relocate. To that end I draw attention to the wide diversity of trades and manufacturers carried on in the town and its surrounding communities:

Agricultural Implements
Amplifying Equipment
Asbestos
Automobile Engineering
Automobile Engineering
Baking and Confectionary
Battery Frame manufacturer
Bedding
Biscuits
Brandy Snap
Brass Working
Brick making
Building and Civil
 Engineering
Cabinet making
Caravan building
Carpets
Chemical manufacturer
Collieries
Commercial Photography

Concrete Flags and
 Kerbs
Cotton Spinning and
 Doubling
Dyeing and Finishing
Electrical Machinery
Electrical Wires and
 Cables
Electro-plating
Engineering
Flour and Grain milling
Furniture making and
 Upholstery
Gramophone Motors and
 Pick-ups
Iron and Steel forging
Laundries
Leather goods
Machine tool manufacturer
Metal Windows

Mineral Water manufacturer
Mustard, Mint and
 Horseradish sauce
Nylon, Rayon and Silk
 spinning
Oil manufacture
Packing cases
Paint manufacture
Patent Glazing
Pre-cast Concrete
Preserving of Fruit and
 Vegetables
Pressings
Printing and Publishing
Pressings
Road and Rail Transport
Rope, Twine and Net
 manufacture
Sand and Gravel products
Saw Milling

Sectional and Portable Buildings	Tanning and Fellmongery	Tweed manufacture
Shoulder Pad manufacture	Tapes and Bands	Wire Brushes
Stone Quarrying	Television and Radio manufacture	Wire manufacture
Surgical and Hospital equipment	Tinned metal Skewers	Wooden containers
	Textile machinery	Woollen and Worsted spinning

The above list was drawn up in 1957 and highlights the wide variety of businesses there were in Brighouse at that time. Sadly, during the sixty years that have followed, many of these industries have disappeared, with many having been replaced by the same or similar products. In most cases these are no longer manufactured in Brighouse and in many instances are now imported from overseas.

I have only been able to look at some of the major contributors to Brighouse's industry in this publication. I'm sure some readers will mention those I have not included – possibly some of those could be included in a future additional volume. Some industries that may surprise you that have been prominent include brewing, shipbuilding, mint and horseradish sauce production, and gramophone component construction to name just a few.

Red Cross Brewery on Foundry street in Birds Royd was established in *c.* 1871 by Messrs Brook and Booth. They were succeeded by Messrs Booth and Ogden, and then later by James Prynn in 1884. Access to the brewery was via an archway in Foundry Street behind a row of two-storey houses. Once inside the archway there were single-storey office premises and an impressive five-storey building that was topped off with castellations, similar to the battlements of a castle keep. The brewery had cellars capable of holding 1,000 barrels. Orders were delivered not only to Brighouse, but to Halifax, Bradford and Huddersfield too.

Red Cross Brewery.

Interestingly, across the road from where the brewery stood is the former Vulcan Inn, which closed in 1926. High up on the front elevation are the initials 'B&B' and the date '1869' – this will date back to Brook & Booth. The brewery was bought in 1902 by Webster's Brewery. All trace of the brewery has now gone.

This is not the only brewery in the Brighouse area, Brear & Brown at Hipperholme opened in 1977 and following various takeovers it closed in 1973 when Bass North moved out.

Mellor's Mint, with its rich, sweet smell, almost took your breath away. On a bad day it hung over the town and, of course, was at its strongest outside their factory in Mill Royd Street. As soon as you turned the corner into the street, whether it was from the Huddersfield Road end or from the opposite end at Briggate, the aroma hit you square in the face. It was particularly strong when the wind was blowing through the streets rather than over the rooftops.

Mellor's opened their business in 1924 not initially as a mint producer, but making mustard. In its early days the very mention of opening a factory to produce mustard in Brighouse must have been considered rather amusing and a bit of a pipe dream that would be out of business pretty quickly. Little did the doubters know that this firm was to become a household name in a comparatively short time.

It is often said that the simple ideas are the best – the idea of selling packaged mint actually came from one of the director's wives. If the mint was washed, kept moist and sold in that condition rather than in the dry form, it could become a saleable item – nice idea, at least in theory. By the 1950s Mellor's were the largest buyers of fresh mint in the country, with one supplier delivering over 275 tons annually. Taking into consideration they had 58,000 square feet of factory space and at their peak were processing 20 tons of mint during one daily nine-hour shift, those readers who cannot remember the company can now probably well imagine the aroma that would have hung over the whole town.

This company was certainly a first for a town that, by tradition, had always employed the majority of locals in engineering, heavy industry or the mills. It was finally bought out by the multinationals when eventually the name of Mellor's Mint was left to the history books.

Arnold Sugden (born in 1912) made receivers and became interested in developing transformers. He has been described as the James Dyson of his time and had no formal education in electronics. During the Second World War he set up his own engineering firm engaged in precision tools. After the war he designed pick-ups, beginning with a moving steel-needle system, making precision turntables. He was inventor of the main contender to modern stereo vinyl. They also made ceramic cartridges with stereo channels. The business closed during the 1980s.

Gramophone advertisement.

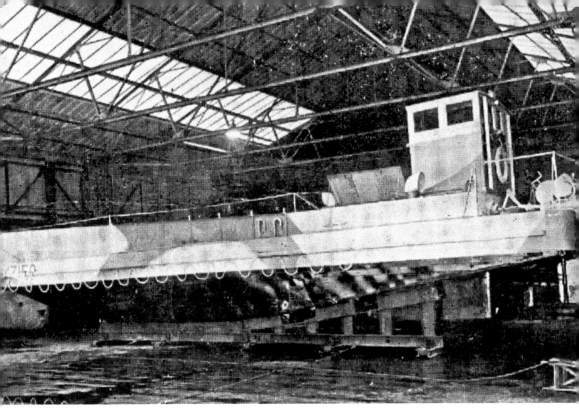

Shipbuilding in Brighouse?!

Up until the Second World War no one would have imagined that Brighouse – some 60 miles from the nearest sea – would build ships. Yet Brighouse did, and was very proud to have contributed to the Second World War in such a significant manner. These were built by T. W. Helliwell at Birds Royd and were called 'Lesson Learnt' by the Navy, the all-welded craft served our country well.

Started in 1870, Helliwell Patent Glazing moved to its current site in Brighouse ten years later. It was during the 1940s that this company, a business more familiar with glazing, turned to the production of shipping. They made each craft 60 feet in length and, once ready, were dispatched from the Brighouse works, ready for sailing.

Why Brighouse? This was during the war years and through repeated bombing in more vulnerable areas in the country Brighouse took on the task of producing these all-welded landing craft. Just how many they produced, I cannot say, but needless to say through the ingenuity and craftsmanship of our local tradesmen, they served our country at its time of need.

In 1959, Helliwell merged with W. H. Heywood's to create Heywood Patent Glazing. The year 1981 saw Heywood Doors & Shopfronts move to the Brighouse site, with Heywood Patent Glazing renamed as Heywood Glazing Systems in 1983.

In 1984 a new factory was built for Heywood Doors and Shopfronts, with the warehouse completed the following year. In 1993, Heywood Glazing Systems & Heywood Doors and Shopfronts merged into Heywood Williams Architectural. As the twenty-first century dawned, the management bought out H. W. Architectural from Heywood Williams Group. Within the last three years the company has seen a major reorganisation across the Brighouse site to make H. W. Architectural an even more robust and competitive company, providing top-quality products. With all this experience this company can proudly say that it is now the leading name in architectural aluminium.

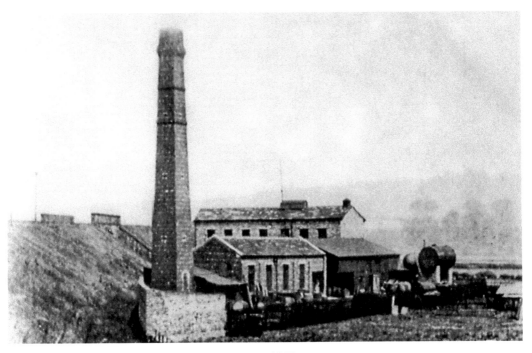

John Drury & Co.'s River Street premises, c. 1909.

One of the industries that is still in existence after 134 years, and still a thriving company is John Drury soap manufacturers in River Street, Birds Royd. In 1882, John Drury, a qualified engineer, was looking to find a way to supply de-gumming silk soap products for the growing textile trade industry. His vision and determination helped create the foundation of today's manufacturing plant located in River Street.

In the 1920s, the business evolved to supply soap powders and bars to the textile and laundry industry. By the 1930s further investment was made to manufacture toilet soap, which created an important sales stream for the business throughout the twentieth and now the twenty-first centuries. Readers may be surprised to know that while John Drury started his business in 1882, there was already a soap-manufacturing business in Brighouse.

That soap works was situated between Upper Bonegate, behind the Ritz and on land that ran to the Bonegate Hall boundary in Bonegate Road. The original business was started in 1847 by two Frenchmen from Rouen under the trading name of Faucon, Rochette & Co. Interestingly, in the *London Gazette* in 1857, André Prosper Rochette of Brighouse registered an invention for improving currying leather.

In 1874, the business was taken over by J. A. Heaton, then changed hands again in 1891 and was renamed Brighouse Soap Co. Ltd. Available records show that in 1895 Joseph Naylor (a partner in John Francis Brown's ironmongery business in Brighouse town centre) was a director at the soap company, along with John Garside, who was the managing director of the soap business.

There were other soap manufacturers in Brighouse too, which appear in a 1906 trade directory: Charles Hanson, Field Head Works, Lightcliffe Road; Leonard Sheffield, Thornhill Road, Rastrick; and John Garside, who has now established his soap business in Little John Mills, Clifton Road. They were all comparatively small businesses alongside the numerous mills, but they all added to the industrial make-up of Brighouse.

Telephone : BRIGHOUSE 1335

EDWARDS (BRIGHOUSE) LIMITED

Sole Manufacturers of the

EDWARDS PATENT POURING DEVICE

This pourer will fit many varying kinds of containers and reduce spillage to practically nothing. Moreover, it can be used in such places as ships, collieries, shops, farms, bakeries, workshops—in fact, almost anywhere — and produce excellent results.

Enquiries are invited

**Save Time and Worry—
—Fit our patent pourer**

VINE WORKS
ELLAND RD., BRIGHOUSE

Here is another Brighouse business that has patented its own invention. This advertisement dates back to 1956. They are no longer in business – what did happen to this company?

A PROCESS VESSEL FROM THE RESIDE WORKS

The products of James Reside Ltd of Tower Works, Birds Royd, were medium- and heavy-fabricated plate work and light structures for the chemical industries.

Telephone No. 523 (2 lines) *Telegrams: "Tussah, Brighouse'*

BRITISH SILK COMBERS
LIMITED

RAYON COMBERS, TOP MAKERS AND GARNETTERS

■

Also REAL SILK COMBERS, RAYON AND SILK NOILS AND WASTES

THORNHILL BRIGGS MILLS
BRIGHOUSE

British Silk Combers advertisement dating back to 1956.

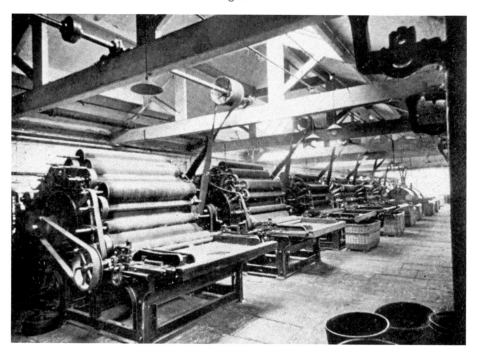

The carding room at British Silk Combers Ltd.

Arthur Holdsworth Leach.

Leach Colour Ltd is based in Bradley (which is in Kirklees, close to the Brighouse boundary) and has been its home since 2005. The business was started in 1891 when Arthur Holdsworth Leach, at the age of twenty, acquired a photographic business in Brighouse. He advertised that 'by carrying out the highest class of work and endeavouring to serve his customers' best interests, he hopes to merit a share of the public favours'.

Arthur had already worked for six years in another photography studio and had risen to the position of studio manager, but he keenly wanted to run his own business. To show support for his son, Arthur's father George gave him a sum of £5. As a joiner at a local carpet factory, George was not a wealthy man but he had managed to save and borrow the money. This sum was the capital with which Arthur's business was started.

Arthur was a fine photographer in the Victorian tradition, whose quality of work was of a high standard – as can be seen from examples surviving to this day. From the outset he was meticulous in producing professionally finished work, fully retouched, mounted and finished prints. It must have been this insistence on high standards in the darkrooms and the workrooms that quickly led him to appreciate the need of practising professional photographers for a specialist print production and finishing service.

In around 1893 Arthur started to undertake print production work for other photographers. There must have been two basic reasons for this decision to change his focus from capturing photographs to printing them. First, the photographic materials of the time were difficult to work with – coarse, textured paper and slow, awkward processes – which the photographer must have been glad to subcontract. Secondly, photography was the booming technology of the time, so there was a rapidly growing potential market.

The business flourished to the extent that, in 1896, Mr Leach purchased a plot of land and built a small photographic workshop. He formed a limited company to finance this and in July 1897 he published a first trade price list.

In 2016 the company known as Leach Colour Ltd celebrated its 125th anniversary. The business has grown enormously since Arthur's dream of owning and running his own photography business, to now become a £10-million-turnover organisation.

During the company's 125-year history, it will have seen all of the industrial changes in Brighouse and many of the businesses that I have illustrated in this book. Many of the Victorian employees and their families will have experienced their first studio portraits here, captured through the magic lens of Arthur Holdsworth Leach.

This book contains just some of the businesses that have helped to put Brighouse on the industrial map. Not just in and around town, but throughout many parts of the United Kingdom and around the world. It is with confidence I can say: 'Brighouse still makes for the world'.